IN AND OUT
OF THE GARDEN

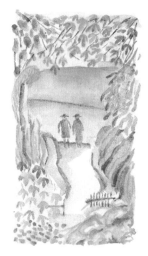

SARA MIDDA

SIDGWICK & JACKSON, LONDON.

FIRST PUBLISHED IN THE UNITED STATES OF AMERICA IN 1981
BY-WORKMAN PUBLISHING COMPANY, NEW YORK.

FIRST PUBLISHED IN GREAT BRITAIN IN 1981~
BY-SIDGWICK AND JACKSON LIMITED.

ISBN: 0-283-98822-3

Printed in Japan,
for~
Sidgwick and Jackson Limited
1, Tavistock Chambers
Bloomsbury Way,
London WC1A 2SG.

Reprinted January 1982

I would particularly like to thank Peter
Workman and Sally Kovalchick for the
chance they offered me to do this book,
and all their understanding & kind-
ness and Sally's sympathetic editorial
assistance. My great appreciation to
Ted Riley for making it all possible &
for his reassuring support throughout.
Also for the kind help and advice from
Paul Hanson, and with many thanks to
Carolan Workman, Wayne Kirn, Jennifer
Rogers and all at Workman Publishing.
To Fritz Wegner for many invaluable
hours so patiently given. To Charlotte
Knox, for garden outings and ideas
exchanged. My parents, Simon, & my
friends for all their encouragement.

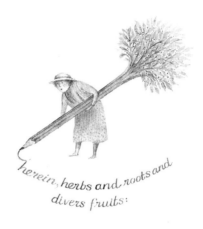

*herein, herbs and roots and
divers fruits:*

CONTENTS.

—•—

"What was Paradise?
but a garden,
an orchard of trees
and herbs, full of
pleasure, and nothing
there but delights."
William Lawson

"The easeful days the dreamless nights
The homely round of plain delights
The calm, the unambitioned mind
Which all men seek, and few men find."
Austin Dobson

"God gave all men all earth to love
But since our hearts are small,
Ordained for each one spot should prove
Beloved over all."
Rudyard Kipling.

"Go where you will through England's happy valleys,
Deep grows the grass, flowers bask
and wild bees hum."
Howitt

"One impulse from a vernal wood may teach
You more of man
Of moral evil and of good
Than all the sages can." W. Wordsworth

"Away, away from men and towns,
To the wild wood and the downs."
Shelley

"Flowers in my time which everyone would praise,
Though thrown like weeds
From gardens nowadays"
John Clare

"Brave flowers,
that I could gallant it like you
and be as little vaine.
You come abroad and make a harmlesse
shew. And to your bedds of earthe againe,
You are not proud you know your birth
For your embroidered garments are from earth."
Henry King 1657

"When to bed the world is bobbing,
That's the time for orchard robbing;
Yet the fruit were scarce worth peeling,
Were it not for stealing, stealing."
 Leigh Hunt.

"And the beech grove,
 and a wood dove,
 and the trail where the shepherds pass;
And the lark's song, and the wind song,
 and the scent of the parching grass."
John Galsworthy

"Who loves a garden, loves a
 greenhouse too."
 William Cowper

"The dandelions and buttercups
Gild all the lawn; the drowsy bee
Stumbles among the clover tops,
And summer sweetens
 all to me."
 J. R. Lowell 1869

"I have a garden of my own..
Shining with flowers of every hue,
 I loved it dearly while
 alone
 But I shall love it more
 with you." Thomas More. 1835

"Here are sweet-peas, a tiptoe for a flight,
With wings of gentle flush or delicate white
Or taper fingers catching at all things
To bind them all about with tiny wings." Keats

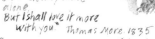

"If you would be happy for a week, take a wife;
If you would be happy for a month, kill your pig;
But if you would be happy all your life,
 plant a garden." Chinese

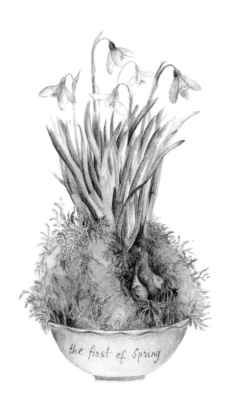

the first of Spring

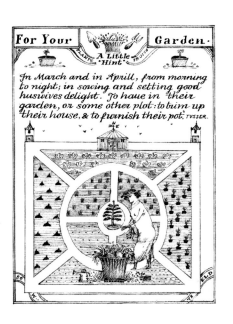

For Your — A Little "Hint" — Garden.

In March and in Aprill, from morning to night; in sowing and setting good huswives delight. To haue in their garden, or some other plot: to trim up their house, & to furnish their pot. TUSSER.

Sorrel~parental affection Longevity. Fig tree~ profuseness

Fig tree~ jealousy

courage Compassion

Elder~ courage

Borage~ sincerity

Fennel~reconciliation

coriander~ concealed...

Apple~ temptation

Strawberry~ perfection

Bay leaves~ glory

Lemon~ zest and symbol of the harvest from bible days

~ disdain fidelity in love

Medlar~ shyness

Lemon blossom

Pear~ joyful marriage and many children

Pea~ joy(of remorse wisdom

Raspberry~ anticipation and domestic economy

Gooseberry~ frugality

Leek~ vivacity

Chicory~ frugality

Endive ~ warmth and cordiality

Olive ~ ...remembrance... ingenuity, energy, tenacity

Rosemary~ initiative

camomile - you please all

cloves~ dignity

fennel~ force and strength

~ gain, profit

Cabbage~ sourness, sharpness, bad temper

barberry~ perfection

~ splendour

Pineapple~ patriotism splendour ~ a quarrel

Corn~ riches. Broken corn~

cress~ stability

cucumber~ criticism

olive ~ peace

lettuce~

blushes. In gypsy lore, a lucky flower for lovers

~ gold he...

arnica~ inspiration

messages from the earth~ compassion courage frugality perfection cold-hearted foolishness war

foolishness

plum tree - on - loves oracle
bilberry tree - treachery
mint - virtue - perform your promise wild plum - independence - HOPE
common spearmint - warmth of sentiment
parsley - almond - warmth of sentiment
blackberry - healing - stupidity, indiscretion almond flower - HOPE
water melon - useful knowledge
rhubarb - advice
mandrake - horror ingratitude bulkiness
balm - sympathy love
quince - temptation
Hop injustice love simplicity
cherry tree - education cure for heartache
cranberry -
orange - generosity
sage - domestic virtue
mushroom - suspicion
marigold - grief
bean - immortality, magic and mysticism
garlic - courage and strength
mustard - indifference and cheerfulness
turnip - charity
balsam - impatience marriage and cheerfulness
citron - ill-natured beauty
pear tree - affection ardent LOVE
cabbage - profit
hyssop - cleanliness
potato - benevolence LOVE
whortleberry - treason good wishes
wheat - hatred sweet basil - good wishes
pennyroyal - flee away

ful knowledge, love, education, generosity, sympathy, shyness, from fruits, vegetables and herbs ~

A
CHOICE
of
GARDENER

"HONESTY in a gardener, will grace your garden, and all your house. Concerning his SKILL, he must not be a Sciolist, to make a shew or take in hand that which he cannot perform, especially in so weighty a thing as an Orchard. The GARDENER had not need be an idle or lazy Lubber, for there will ever be something to do. Such a GARDENER as will conscionably, quietly and patiently travel in your Orchard, God shall crown the labours of his hands with joyfulness, and make the clouds drop fatness upon your trees; He will provoke your love, and earn his wages and fees belonging to his place. The house being served, fallen fruit, superfluity of Herbs and Flowers, Seed, Graffs, Sets, and besides all other of that Fruit which your bountiful hand shall reward him withal, will much augment his wages, and the profit of your Bees will pay you back again. If you be not able, nor willing to hire a GARDENER, keep your profits to your self, but then you must take all the pains".

LAWSON

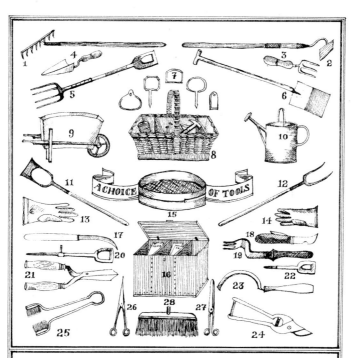

1: Rake 2: Hoe 3: Hand Fork 4: Trowel 5: Fork 6: Spade
7: Labels of assorted sizes for plants and trees 8: Basket
for small tools, string, hammers and nails 9: Wheelbarrow
10: Watering can 11: Dutch hoe for undercutting weeds 12:
Pitchfork 13: Right handed glove 14: One for the other hand
15: Hand sieve 16: Seed box 17: Budding knife 18: Pruning
knife 19: Daisy Grubber 20: Dibbler with foot rest used
for potatoes 21: Shears 22: Small dibbler or dibble 23: Scythe
24: Secateurs 25: Aphis brush 26: Scissors for grapes 27:
Scissors for flower gathering 28: Stiff brush long handled.

"by sowing
wet is little
to get."

"To protect seedlings
from byrdes, antes, field-
mice and other spoylers of
the garden – sprinkle with
juice of house leek on seed
before sowing." T. HYLL

soil must be of the right
condition for sowing–when it
is neither very dry–nor very wet;
it is then moist, but not
wet. It has the appearance
of having been watered
and is easily
crumbled to
pieces in the
hand.

water seedlings
with a rose attachment

when seeds
in the packet
stick together,
mix with a
little sand

then sprinkle
them out:
between
fingers or on
shiny folded
paper.

plants from
tender seedlings
grow–so water each but
with a gentle
drop.

if seeds
are slow
to begin to
germinate–
water and

then
cover
with mats or
sacks – which
are removed at
first sign of
sprouting.

make seed drills with a stick or
some such object, following a string
line, to keep as straight as possible.

soak seeds in scented
water, then dry them in
the sun, then the fruits will
have the same savour as the liquid.

Sow early lettuces in seed beds - then prick out and transplant. From June sow thinly in rows where they remain undisturbed - thinning early in their life.

In winter the ground should be dug and prepared for sowings of:

Sow of each sort at ten day intervals so there may be a continuous harvest and no disappointment should one batch fail.

water seeds right after sowing to settle the soil to a uniform surface. Thereafter light waterings - without missing an evening.

lettuces are most accommodating plants for a catch crop. A first year strawberry plot can be well intercropped by them.

Corn salad sown from February to -

october though best in August when lettuces are over.

Runner and French beans are too tender to stand the slightest frost; They can be sown in boxes under glass and transplanted at the end of May.

"sow beans in the mud, they'll grow like wood."

The cabbage tribe should be sown in seed beds, and then the young ones picked out, to induce strong plants, and to prevent crowding. Then plants put into their permanent homes with the aid of a trowel.

plant some best old carrots for seeds

When to Sow ~ and How to Grow ~
~Various Vegetables~
From Seed

VEGETABLE	D.	G.	M.	L.	FOR SOWING
ASPARAGUS	2	14–25	165	3	APRIL
BASIL	1/2	6–8	20	8	APRIL/MAY
BEANS–BROAD	1	7–14	18	3	FEBRUARY/APRIL
BEANS–RUNNER	1	7–14	14	3	APRIL/JULY
BEETROOT	2	10–18	17	6	APRIL/MAY
CABBAGES	1/2	6–8	20	5	MARCH OR JUNE
CARDOONS	1	15–20	24	7	APRIL/MAY
CARROTS	1/4	12–18	22	4	MARCH/AUGUST
CORN SALAD	1/4	8–10	10	4	MARCH/AUGUST
CRESS	1/2	3–4	1 1/2	5	MARCH/SEPT
ENDIVE	1/2	6–12	16	10	JUNE/AUGUST
LEEK	1/2	10–12	32	3	MARCH
LETTUCE	1/2	6–12	10	5	MARCH/SEPT
MUSTARD	1/2	5–6	1 1/2	4	MARCH/SEPT
PARSNIP	1	15–21	32	2	FEBRUARY/MAY
PEA	2	7–12	16	3	MARCH/JUNE
RADISH	1/2	4–6	6	5	MARCH/SEPT
SAGE	1/2	10–14	18	3	APRIL
SPINACH(perpetual)	1	10–18	11	5	MARCH
SPINACH (Summer)	1	10–18	11	5	AUGUST
THYME	1/4	10–14	52	3	APRIL
TOMATO	1/2	7–14	24	4	MARCH/APRIL
TURNIP	1/2	5–7	13	2	APRIL/JULY
VEG. MARROW	1	7–14	15	6	MARCH/APRIL

D: The depth, in inches, to sow your seeds G: The time, in days, they
take to germinate. M: The time in weeks to reach maturity, and
L: The number of years that seeds may be kept before planting.
Years, days, months, weeks and even inches are an approximation ~

"GATHER ALL YOUR SEEDS, DEAD, RIPE AND DRY."
Rub seeds of all sorts of plants from their husks, pods or what
ever, store in a dry place in envelopes until sowing time comes

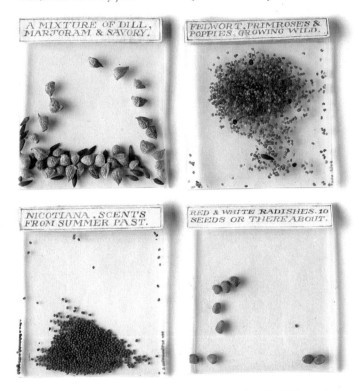

A MIXTURE OF DILL,
MARJORAM & SAVORY.

FELWORT, PRIMROSES &
POPPIES, GROWING WILD.

NICOTIANA, SCENTS
FROM SUMMER PAST.

RED & WHITE RADISHES. 10
SEEDS OR THEREABOUT.

"To test seeds for soundness before planting: Put them in
a glass of warm water, and those that after an hour have
not sunk should be rejected. Carrots and such like seeds,
should be rubbed to remove part of the hairs which would
otherwise act as the feathers do as to a duck." Cobbett

when the morning hour
shows—into the garden
to see what grows.

full summer, hold it a jug.

a lawn that's rolled
is much extoled

on greenhouse shelves

Little Broad Beans

Picked when but
they're young, cook
lightly, roll in
parsley & butter

pots of surprises
as each shoot rises

radishes . carrots

fresh pulled of soil
are always joy
and never toil.

a glass-cloche.

will well protect,
plants that cold
may ill affect.

currants with cream

grapes or a berry,
these fruits of dreams
that make us merry

from a lead tank—
flowers do pour, may
they come for a year
or more.

one peaches on a summer's eve
the
stone's the
only part
you leave.

weeding, staking,
hoeing, raking,
a few tasks—

of garden making

—upon a mobile
garden seat~
we'll chase the sun
or shield from heat.

roseberries and currants and a gooseberry too...
'mongst the berries I bring to view...

growing a plant stand many flowers—

for tumbling colours
of scented hours

" In well sieved earth "
the seeds give birth

seedlings grow in
rare profusion,
leaves and stems
in great confusion.

when summer's dry
no rain from sky
the sun's no shorter
—I'm off to water.

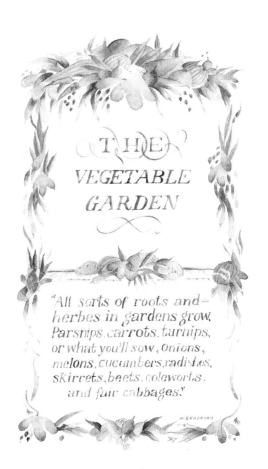

THE
VEGETABLE
GARDEN

"All sorts of roots and—
herbes in gardens grow,
Parsnips, carrots, turnips,
or what you'll sow, onions,
melons, cucumbers, radishes,
skirrets, beets, coleworts,
and fair cabbages."

LEEK – So commonly grown in Saxon days, 'leac tun' was a name for the Kitchen garden – the small plot we call a 'cabbage-patch'. Cultivated in ancient Egypt.

RADISH – From the Latin – Radix – Root. 'Do not eat before sleeping for it will cause you to wake with a stinking breath'. At Levens Hall, there is a Radish Feast where the gentry & mayor meet & eat Radishes & Bread.

CABBAGE – The Romans who used cabbage for its medicinal use, as well as a culinary favourite, brought it to Britain, though a wild variety grew as far back as the Iron Age.

PARSNIP – A native plant cultivated since Roman times. Because of their sugar content, in Elizabethan days they were used in sweet dishes, preserves, jams & pies.

CHILI – Like capsicums, the Spanish in Peru grew them, and as a punishment to their slaves they cruelly squeezed the juice into their eyes resulting in great pain. Very useful in cooking tasty dishes.

ARTICHOKE – from the Arabic ardischauki – Earth-thorn. Pliny tells of them being one of the luxury vegetables of his time, & with sarcasm says though they are eaten by men, animals avoid them.

AUBERGINE – Egg plant, Mad Apple, or Brinjal. Native to the tropics, imported to Europe in fifteenth century, but they were chiefly grown for decorative purposes.

ONION – "This is ev'ry cook's opinion, no sav'ry dish without an onion: But lest you Kissing should be spoil'd, your onions must be throughly boil'd." Swift.

PEA – Of old origin. Grown in Henry VIII's reign in England. In George III's reign his birthday marked a season with gardeners – for on the fourth of June, peas were expected to be ready for the table.

CORN ON THE COB, SWEETCORN – William Cobbett after returning from a long stay in America recommended its cultivation here – and we are grateful to him for such a good dish.

TURNIP – 'Nep' is the old English word for a root vegetable. Boiled it "nourysheth moch, augmenteth the sede of man, provoketh carnall lust." Thomas Elyot

CHICK PEA – From chick and pea – "A kind of degenerate pea" – MILLER Originally called Chiche, and after the French Pois Chiche, in the 18th century changed to Chick Pea.

CELERIAC – also called turnip rooted celery. One of the celery family it was grown in England from the 18th century – delicous when peeled, sliced and eaten raw.

CORN SALAD or **LAMB'S LETTUCE** – in Latin – 'Lactuca Agnina' – from appearing at the time when lambs are dropped, or perhaps as it is a favourite of lambs. First salad of the year.

SPROUT – originated from Brussels – hence the name Brussels Sprouts. Introduced to Britain around the eighteenth century.

TOMATO – 'Love Apple' of 1596 when brought here. Regarded as a novelty, without much table value. From S. America, name derived from Aztec name – tomatl – meaning 'swelling fruit'.

LETTUCE – Lactuca Sativa – From the old French – laitue – milk. Thought to have similar narcotic properties as opium, which reside in the milky juice. "Maketh a pleasant salad."

SKIRRET – From the Dutch – Suikerwortel – sugar root, for that is their taste. "The women in Suevia, prepare the roots hereof for their husbands, and know full well wherefore & why etc." Gerard.

WATER-CRESS – Perhaps from Old German – chresan – to creep. Romans said it was a cure for those minds that were deranged – hence the Greek proverb – 'Eat cress and learn more wit.'

PUMPKIN – From the French pompon 'a pumpion or melon'. A useful vegetable as it keeps well, and therefore is often used in the winter months for pumpkin pies.

CHICORY – the roots when dried and ground are often added to coffee. The leaves make a good salad, dressed with lemon juice, oil and seasoning.

KALE or **BORECOLE** – which is the Anglicized word for the Dutch 'boerenkool' which is 'Peasant's Cabbage'. – as Kale grows on the poorest of soils, and needs little care taken of it.

BEETROOT - BETA VULGARIS - so called for when the seed pods swell up, they bear a great likeness to the Greek letter beta.

BROAD BEAN - cultivated in prehistoric Egypt and Arabia, and a smaller version in Iron-Age Britain. Delicous when eaten young and removed from its fur-lined protective pod.

MARROW - pulp or the inside part of the fruit. Easily grown, and reaching great sizes, people compete for producing the largest one.

POTATO — First found in Ecuador, where it was called 'batata'. Sir Walter Raleigh brought it to England, and for a long time they were regarded as a delicacy.

CARROT — "winneth love and helpeth conception." In the Hebrides they were collected by young women, to give as dainties to their friends on Sundays and at dances.

ASPARAGUS - Used to be called 'sparrow-grass'. Native plant, and found growing wild on the southern coasts, on the Polish steppes, in Greece or wherever the air is salty.

SPINACH - Introduced around 1570. Parkinson writes "Spinach is an hearbe fit for sallets... many English that have learned it of the Dutch, do stew the herb in a pot without moisture."

SWEDE — Introduced first of all from Sweden to Scotland in 1781. 'Swede greens be the top of all physic.'

CUCUMBER — One of the oldest cultivated plants, popular in China, Egypt & India for thousands of years. "How cucumbers along the surface creep, with crooked bodies, and with bellies deep." Dryden.

MUSHROOM - 'An upstart; a wretch risen from a dunghill.' 'Mushrooms come up in a night, & yet they are unsown, and so such as are upstarts in state, they call in reproach Mushrooms.' Bacon

BEANS - "Sow beans in mud, they'll grow like wood." "The seeds dried, are much employed in soups aboard ships."

CAULIFLOWER - "Of all the flowers in my garden, I like the cauliflower." Dr. Johnson. "The most delicate and curious of the whole of the Brassica tribe." Loudon.

BROCCOLI — Philips thinks of Broccoli as "an accidental mixture of the common cabbage and the cauliflower."

KOHL RABI - A German name - a cabbage turnip - a cabbage whose stem is so swollen so as to look like a turnip. Introduced from Italy.

COURGETTE - from the French 'courge'- Marrow - for this is a small member of that family, and picked when quite young. Also known as zucchini. Eaten in many ways, cooked or in salads.

CELERY — the cultivated form of smallage - which is found growing wild with a disagreeable taste and smell. The cultivated and blanched plant is quite different, it is not known who thought of this.

SQUASH — From the cucurbita family - the summer sadash in England is known as the pumpkin. Used in soups, pies or baked as a vegetable dish.

PEPPER · CAPSICUM — reached Europe through the Spanish conquerors of Peru, who cultivated both peppers and chili for their own diet and also exported them.

JERUSALEM ARTICHOKE — of the same family as the sunflower, its name may come from the Italian for sunflower - 'girasole'. The soup made from it is called Palestine.

SORREL - In French surelle, from German suur-sour - for this is the taste of the leaves. "Of all roots of herbs, the root of sorrel goeth the farthest into the earth." Miller.

ENDIVE — probably came to England from Egypt - for it was grown there at the time of the Pharaohs. Pliny talks of its use as a salad vegetable for which it is excellent.

SALSAFY - "They make a pleasant dish of meate, farre passing the Parsnnep in many mens judgements." Parkinson.

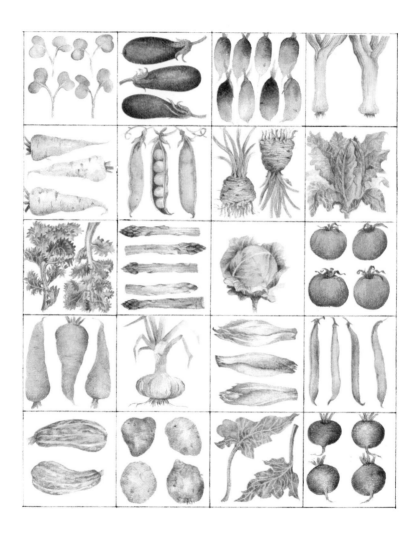

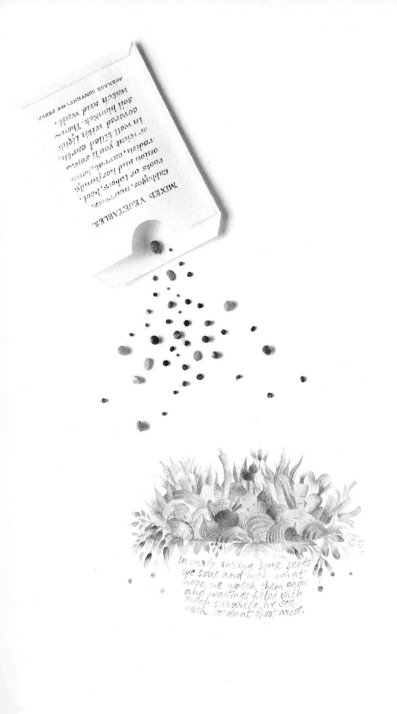

Runner Beans, French Beans, Broad Beans to name but a few, sliced or shredded, in pods or out, I'll serve to you. Boiled or steamed, with herbs, butter or sauce, cold or hot, must surely be a welcome dish to any pot, to eat in the summer hours, under an arbour of bean-flowers.

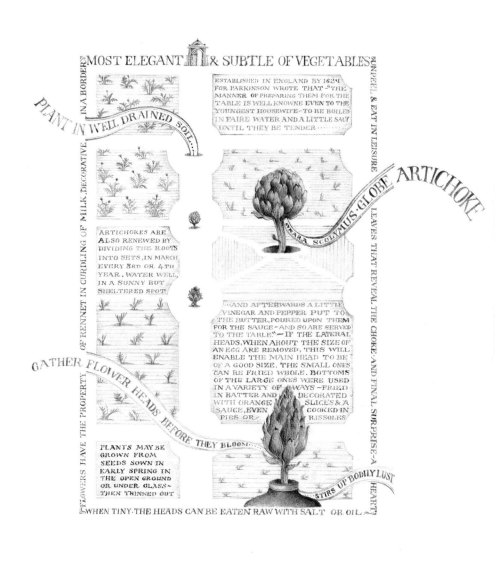

MOST ELEGANT & SUBTLE OF VEGETABLES

IN A BORDER · PLANT IN WELL DRAINED SOIL

DECORATIVE · OF RENNET IN CURDLING OF MILK · FLOWERS HAVE THE PROPERTY

GATHER FLOWER HEADS BEFORE THEY BLOOM

UNPEEL & EAT IN LEISURE · LEAVES THAT REVEAL THE CHOKE · AND FINAL SURPRISE · A HEART · STIRS UP BODILY LUST

CYNARA SCOLYMUS · GLOBE ARTICHOKE

WHEN TINY · THE HEADS CAN BE EATEN RAW WITH SALT OR OIL

ESTABLISHED IN ENGLAND BY 1629
FOR PARKINSON WROTE THAT — "THE
MANNER OF PREPARING THEM FOR THE
TABLE IS WELL KNOWNE EVEN TO THE
YOUNGEST HOUSEWIFE · TO BE BOILED
IN FAIRE WATER AND A LITTLE SALT
UNTIL THEY BE TENDER · · · · · · · ·

ARTICHOKES ARE
ALSO RENEWED BY
DIVIDING THE ROOTS
INTO SETS, IN MARCH
EVERY 3RD OR 4TH
YEAR, WATER WELL,
IN A SUNNY BUT
SHELTERED SPOT.

· · · AND AFTERWARDS A LITTLE
VINEGAR AND PEPPER PUT TO
THE BUTTER, POURED UPON THEM
FOR THE SAUCE — AND SO ARE SERVED
TO THE TABLE" — IF THE LATERAL
HEADS, WHEN ABOUT THE SIZE OF
AN EGG ARE REMOVED, THIS WILL
ENABLE THE MAIN HEAD TO BE
OF A GOOD SIZE. THE SMALL ONES
CAN BE FRIED WHOLE. BOTTOMS
OF THE LARGE ONES WERE USED
IN A VARIETY OF WAYS — FRIED
IN BATTER AND DECORATED
WITH ORANGE SLICES & A
SAUCE, EVEN COOKED IN
PIES OR RISSOLES

PLANTS MAY BE
GROWN FROM
SEEDS SOWN IN
EARLY SPRING IN
THE OPEN GROUND
OR UNDER GLASS —
THEN THINNED OUT

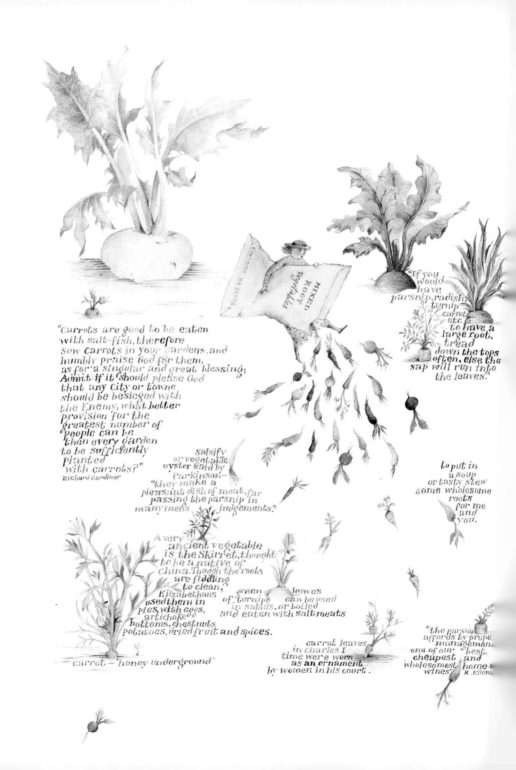

MIXED ROOT vegetable

"Carrots are good to be eaten with salt-fish, therefore sow carrots in your gardens, and humbly praise God for them, as for a singular and great blessing; Admit if it should please God that any City or towne should be besieged with the Enemy, what better provision for the greatest number of people can be then every garden to be sufficiently planted with carrots?"
Richard Gardiner

"If you would have parsnip, radish, turnip, carrot etc. to have a large root, tread down the tops often, else the sap will run into the leaves."

Salsify or vegetable oyster said by Parkinson— "they make a pleasant dish of meat, far passing the parsnip in many mens judgements."

to put in a soup or tasty stew some wholesome roots for me and you.

A very ancient vegetable is the Skirret, thought to be a native of China. Though the roots are fiddling to clean, Elizabethans used them in pies, with eggs, artichoke bottoms, chestnuts, potatoes, dried fruit and spices.

green leaves of turnips can be used in salads, or boiled and eaten with salt meats

carrot — 'honey underground'

carrot leaves in Charles I time were worn as an ornament by women in his court.

"the parsnip affords by proper management one of our best, cheapest and wholesomest home-made wines" R. Ellom

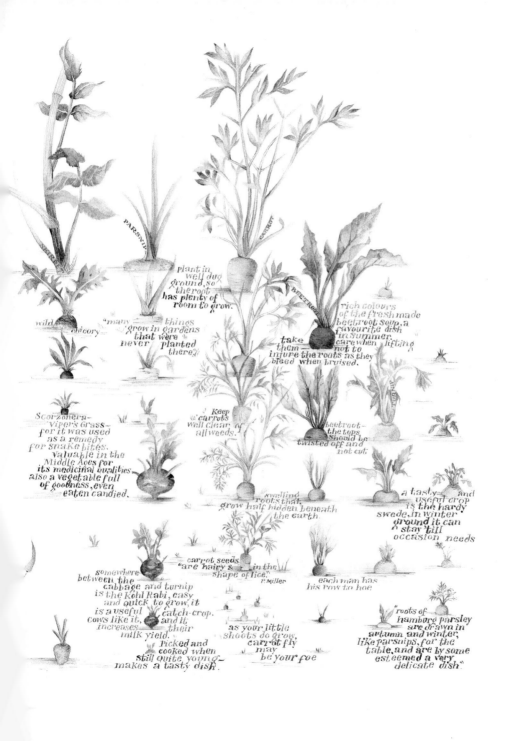

plant in well dug ground, so the root has plenty of room to grow.

CHICORY PARSNIP CARROT BEETROOT

wild chicory

"many things grow in gardens that were never planted there"

rich colours of the fresh made beetroot soup, a favourite dish in Summer. take care when lifting them not to injure the roots as they bleed when bruised.

Scorzonera - Viper's Grass - for it was used as a remedy for snake bites. Valuable in the Middle Ages for its medicinal qualities, also a vegetable full of goodness, even eaten candied.

Keep carrots well clear of all weeds.

beetroot - the tops should be twisted off and not cut.

a tasty and useful crop is the hardy swede, in winter ground it can stay 'till occasion needs

swelling roots that grow half hidden beneath the earth.

somewhere between the cabbage and turnip is the Kohl Rabi, easy and quick to grow, it is a useful catch-crop. Cows like it, and it increases their milk yield. Picked and cooked when still quite young - makes a tasty dish.

carrot seeds "are hairy & in the shape of lice." P.Miller

each man has his row to hoe

as your little shoots do grow, carrot fly may be your foe

"roots of hamburg parsley are drawn in autumn and winter, like parsnips, for the table, and are by some esteemed a very delicate dish"

"and God said,
let the earth bring forth grass, the
herb yielding seed, and 'the fruit-
tree yielding fruit after his kind,
whose seed is in itself upon the earth."

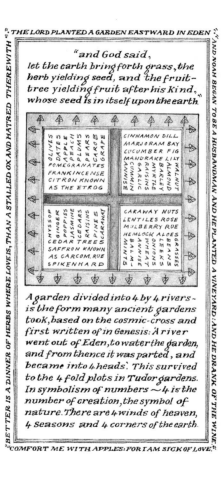

A garden divided into 4 by 4 rivers -
is the form many ancient gardens
took, based on the cosmic-cross and
first written of in Genesis: 'A river
went out of Eden, to water the garden,
and from thence it was parted, and
became into 4 heads'. This survived
to the 4 fold plots in Tudor gardens.
In symbolism of numbers ~ 4 is the
number of creation, the symbol of
nature. There are 4 winds of heaven,
4 seasons and 4 corners of the earth.

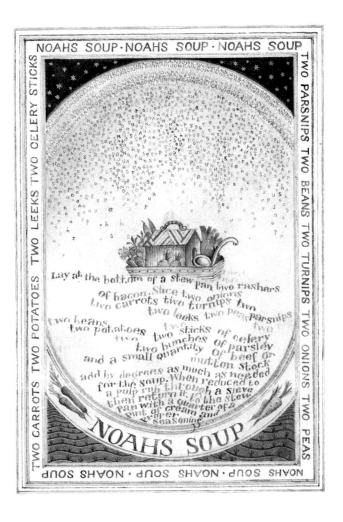

NOAHS SOUP · NOAHS SOUP · NOAHS SOUP

TWO LEEKS TWO CELERY STICKS

TWO PARSNIPS TWO BEANS TWO TURNIPS TWO ONIONS TWO PEAS

TWO CARROTS TWO POTATOES

Lay at the bottom of a stew pan two rashers of bacon. Slice two onions two carrots two turnips two parsnips two leeks two peas two two beans two potatoes two sticks of celery two two bunches of parsley and a small quantity of beef or mutton stock add by degrees as much as needed for the soup. When reduced to a pulp rub through a sieve then return it to the stew pan with a quarter of a pint of cream and proper seasoning.

NOAHS SOUP

NOAHS SOUP · NOAHS SOUP · NOAHS SOUP

It has many virtues — good for those with dim eyesight, for swellings, & the juice good for gout — though extremely bruises gout.

Cabbage — (Brassica tribe)

Many varieties of cabbages — and assorted colours — they are extremely hardy plants

Sir Anthony Ashley brought the first cabbages to England from Holland, he is represented in his monument with a cabbage at his feet.

One of the most ancient and popular vegetables

The Romans were very fond of the cabbage, and Cato thought it the best of vegetables

The name 'cabbage', is from the Latin 'caput' meaning — a head.

Forms part of the table supply in one form or another, from the first day and In January to the last day of December.

What more delightful than to behold dishes of wholesome plants gathered from hedgerow, garden or field, sallets adorned with flowers ~ rose petals, cowslips, violets, primroses, rosemary, gillyflowers, nasturtium, wild thyme or marigold, to name a few. Surely salads to bring joy to any table? And for the winter, to have a 'Preserved Sallet' of these flowers, having kept them in vinegar.

A Grand - Sallet, of an old tradition - Blanched almond raisins, olives, capers, and finely shredded red sage, tarragon, samphire and slivers of eggs ~ Spinach, oil, vinegar and sugar, then layers of thinly sliced red cabbage, oranges and lemons, scattered with olives, pickled ~ cucumbers and shredded lettuce. Perhaps an oyster or two, cold chicken or a pike to add, and aloft, a sprig of rosemary to be hung with cherries.

A Salad ~ Not to eat, but for show. A root vegetable cut into various fantastic ~ forms.

Salamagundi - An Early English Salad. In the centre of a round dish, to mark the sun place a chicory or endive, and define its circumference with bands of herring strips, zones of chopped chicken, egg yolks, a green orb of parsley, minced veal, tongue, beef or whatever you wish, and let the outlying region be a garland of sprigs of watercress. Then the whole of this cosmic dish inserted with gems of radishes, capers, olives and the tiniest onions.

A Meal of ~ Young greens washed, and gently dried in a fine clean towel, spread upon a platter and mixed with a dressing. Of these may be ~ spinach, succory, tansy, primrose and violet leaves, hyssop, thyme, tarragon, marjoram, leeks, a lettuce, salad burnet, purslane, corn salad, cowslip leaves, cress, borage, chervil or vine-tendrils, and even the boiled, candied or pickled roots of the daisy, fennel, parsnip, carrot or angelica, to add to your salad ingredients.

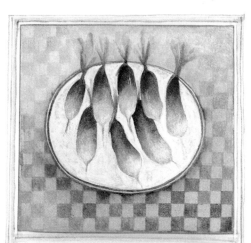

A dish of radishes
A slice of bread
To spread some butter
In the midday sun.

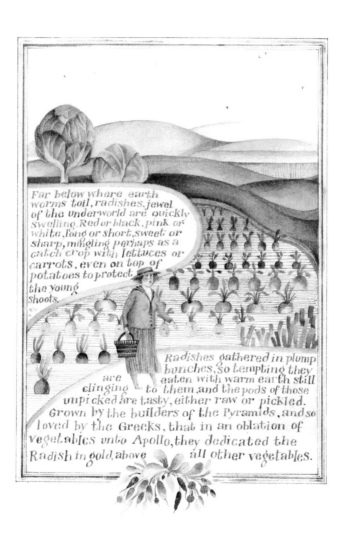

Far below where earth
worms toil, radishes, jewel
of the underworld are quickly
swelling. Red or black, pink or
white, long or short, sweet or
sharp, mingling perhaps as a
catch crop with lettuces or
carrots, even on top of
potatoes to protect
the young
shoots.

Radishes gathered in plump
bunches, so tempting they
are eaten with warm earth still
clinging to them, and the pods of those
unpicked are tasty, either raw or pickled.
Grown by the builders of the Pyramids, and so
loved by the Greeks, that in an oblation of
vegetables unto Apollo, they dedicated the
Radish in gold, above all other vegetables.

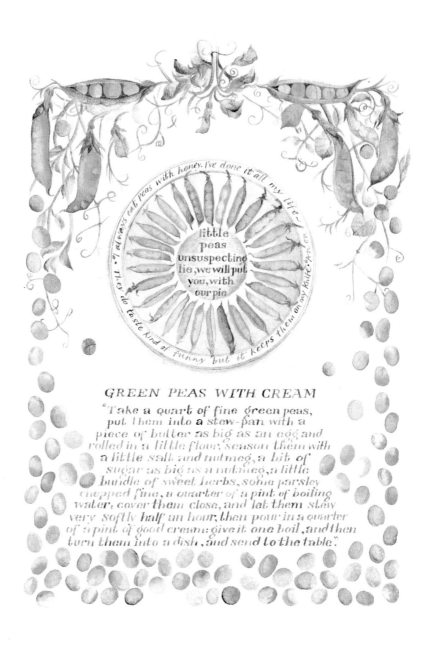

I always eat peas with honey. I've done it all my life—

They do taste kind of funny but it keeps them on my knife.

little
peas
unsuspecting
lie, we will put
you, with
our pie

GREEN PEAS WITH CREAM

"Take a quart of fine green peas,
put them into a stew-pan with a
piece of butter as big as an egg and
rolled in a little flour, season them with
a little salt and nutmeg, a bit of
sugar as big as a nutmeg, a little
bundle of sweet herbs, some parsley
chopped fine, a quarter of a pint of boiling
water, cover them close, and let them stew
very softly half an hour, then pour in a quarter
of a pint of good cream; give it one boil, and then
turn them into a dish, and send to the table."

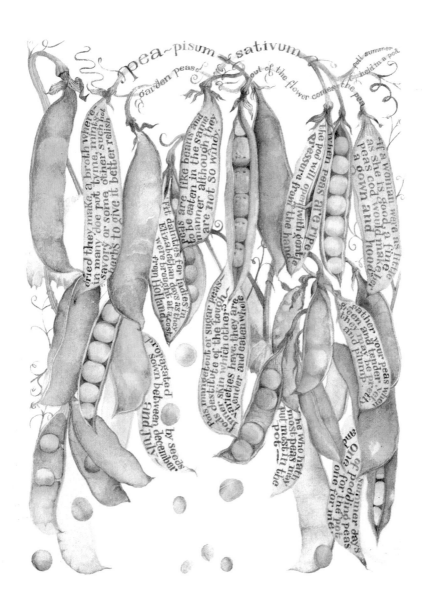

pea—pisum—sativum

garden peas ... out of the flower comes the pea ... held in a pot ... full summer

dried they make a broth where in many doe put tyme, mintt, savory or some other such hot harbs to give it better relish

Pea are like beans and to be eaten in the same manner although they are not so windy

Fit dainties for ladies as they were brought at a cost from Holland

when peas are ripe the pod will open with gentle pressure from the hands

if a woman were as little as she is good, a fine as cod would make peas, peas down and hood

marrofatt or sugar peas destitute of the tough spur skin which others varieties have, they are tender and eaten whole

gather your peas when green and tender they may be held and plumb

propagated by seeds sown between december and July

he who hath most peas may put most in the pot

One of summer days of podding peas one for the pot one for me.

"Good huswives in summer will save their own seedes
Against the next yere ~ as occasion needes.
One seede for another, to make an exchange
With fellowlie neighbourhood seemeth not strange."

THOMAS TUSSER

SHINE THE SUN · EARTH WORMS AERATE

PLANT BELOW EARTHS SURFACE · WATER ·

A SEED OF SUMMER TO
KEEP THROUGH A WINTER
TO PLANT IN SPRING ·

Eternal Bud

Seeds

what could they be

A THOUGHT
from
My garden

CONTENTS: 20 SEEDS

HEREIN SOME SEEDS

I HOPE · NOT WEEDS?

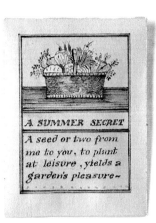

A SUMMER SECRET

A seed or two from
me to you, to plant
at leisure, yields a
garden's pleasure~

Apple pips shot from between fingers point towards lover's abode.

Dropped apple parings fall in the shape of ~ your lover's initials.

A plant from a friend will grow & flourish, but one from a false-giver will surely wither & die.

To catch a falling leaf foretells 12 months happiness.

a slice of lemon under the chair of a visitor-insures his friendship...

A maiden & youth who eat the same beet-fall in love.

People wearing flowers with stems pointing upwards, are in love~

CUSTOMS

OF LOVE·

Put 3 barleycorns under the pillow & dream of your love.

Throw onions after a bride-you throw away her tears.

Send a 'love-Apple (tomato) to ~ one you love & whom you wish to love you, for it will induce him to do so.

'Peascod-wooing'-if you find a pod with nine peas in it, lay it on the

lintel of the kitchen door. The first man to enter, will be your love.

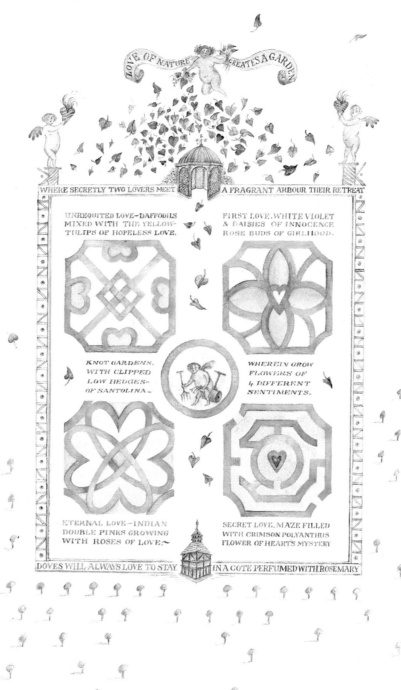

LOVE OF NATURE CREATES A GARDEN

WHERE SECRETLY TWO LOVERS MEET A FRAGRANT ARBOUR THEIR RETREAT

UNREQUITED LOVE—DAFFODILS
MIXED WITH THE YELLOW-
TULIPS OF HOPELESS LOVE.

FIRST LOVE, WHITE VIOLET
& DAISIES OF INNOCENCE
ROSE BUDS OF GIRLHOOD.

KNOT GARDENS,
WITH CLIPPED
LOW HEDGES-
OF SANTOLINA ~

WHEREIN GROW
FLOWERS OF
4 DIFFERENT
SENTIMENTS.

ETERNAL LOVE—INDIAN
DOUBLE PINKS GROWING
WITH ROSES OF LOVE:~

SECRET LOVE, MAZE FILLED
WITH CRIMSON POLYANTHUS
FLOWER OF HEART'S MYSTERY

DOVES WILL ALWAYS LOVE TO STAY IN A COTE PERFUMED WITH ROSEMARY

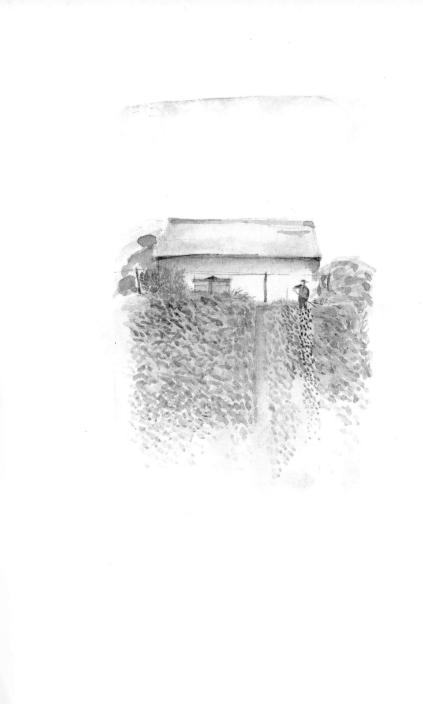

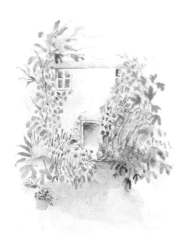

What is more delightful
than a cottage garden?
An unstudied profusion of plants so
well loved, they hold ones heart more
than any formal garden ever can.
In rows and patches, on different levels,
each curious shape filled like some
flowered tapestry. Daffodils and
primroses rise from the grass, their natural
home. Here, a gooseberry bush has
seeded, and dog rose entwines crab-
apple, burning tree of summer.

Clematis lingers in flowering
canopies over summer
branches.
Worn brick paths with
moss filled cracks.
Plant encrusted walls.
Aubretia clumps.
Hidden windows.
Wild roses over
a cottage door.
Bowers of honeysuckle.
In a sequestered spot-
a rustic bench.
currant bushes, hung
with clusters of
berries.
Onions, carrots,
cabbages, lettuces
and radishes, fresh vegetables, decorative in their
striped rows, mix with broad leaved herbs and drifts
of flowers. Each fills the garden with its own charm.

small plots, like
rooms extended,
where cottage and
garden seem
to merge.
outdoor spills inside, to
deep set window sills, where
geraniums in earthenware
pots, vie for the light.

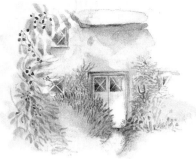

Someones secret summer,
 someones silent thoughts.
 Herb lined pathways
 where one pauses to squeeze
 the lemon balm, sighs and continues.
Around the door, lavender, night scented stocks,
 tobacco plants and a vine. The cottage flowers that take
one back to gardens past – sweet peas on tripods, hollyhocks, pinks,
 columbines, limnanthes, bleeding heart, blue geraniums,
 cranesbill, ladies mantle, and here and there, the unannounced
 arrival of some self sown annual.

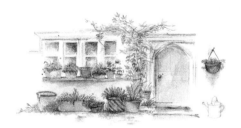

A cobbled courtyard, striped
 flower pots, troughs, various
 containers, moved as the
 seasons change. Wild
 strawberries for an instant
 breakfast feast. Corn salad
 crowns an ageing pot.
In a hanging wire basket, lined
 with moss, and filled with earth
 grows parsley, shooting at
 all angles to form a
 green herbal ball.

At the gate entwined with scarlet runners and everlasting–
 peas is a bucket filled with little
 bunches of flowers, that so
 perfectly combine all of
 natures colours – A rose,
 pansies, scabious,
 poppies, gypsophilia,
 cornflowers, marigolds,
 and sprigs of scented
 herbs.
 A bowl of apples
 at the end of a
 plentiful crop–
 for you to
 take.

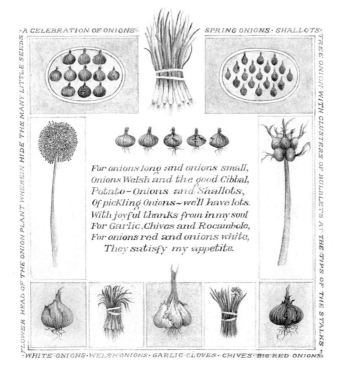

For onions long and onions small,
Onions Welsh and the good Cibbal,
Potato~Onions and Shallots,
Of pickling Onions~we'll have lots.
With joyful thanks from in my soul
For Garlic, Chives and Rocambole,
For onions red and onions white,
They satisfy my appetite.

FLOWER HEAD OF THE ONION PLANT WHEREIN HIDE THE MANY LITTLE SEEDS

TREE ONION WITH CLUSTERS OF BULBLETS AT THE TIPS OF THE STALKS

"Early in the Spring, whilst the weather is cold, be cautious of watering
the leaves of the young and tender Plant, only wet the earth about it.
When your plants or seeds are more hardy, and the Nights yet cold,
water in the fore-noons; but when the nights are warm, or the days
very hot, then the evening is the best time.
If you draw your water out of Wells, or deep Pits, it ought to stand a day in
the Sun in some Tub, or such like, for your tender plants in the Spring.
But pond, or river, or Rain-water needs it not, and is to be preferred
before Well-water, or Spring-water.
For coleflowers, artichokes and such like, let the ground sink a little
round the plant in form of a shallow dish, the water will the better,
and more evenly go to the roots.
Water not any plant over-much, lest the water carry with it away the
Vegetative or Fertil Salt; and so impoverish the ground & chill the plant.
It is better to water a plant seldom & thoroughly; than often & slenderly;
for a shallow watering is but a delusion to the plant, and provokes it to
root shallower than otherwise it would, and so makes it more obvious
to the extremity of the weather.
The water is very good that is taken out of standing Pools, where the
cattel usually resort to shade or cool themselves in hot weather, and
leave their dung in it, by which the stirring of their feet enricheth
the water; Ducks and geese also much improve standing pools—
where they are frequent." John Worlidge.

Sprouts for dinner,
Sprouts for ten,
Sprouts for you,
and Sprouts for me.
Sprouts at Christmas,
Sprouts at Fall.
Whether large
– or whether small,
Sprouts enough to fill us all.

A Childhood Garden of Ones very own

~ A LITTLE PLOT
A PRIVATE PLACE ~
is ours to dig and cultivate

my own tools

DO YOU REMEMBER? careful watering of rows we planted, that changed from strange seeds into flowers,

and the ones that didn't, when temptation proved too strong and we peeped beneath the soil to investigate the growth.

PLANTS THAT DID NOT SURVIVE THEIR ROOTLESS TRANSPORTATION **from some** one's flower bed ~ to our own plot. Buds we opened in impatient curiousity and shoots we gently aided through the earth.

GARDEN TRANSPORT you who pushed the barrow for joyful rides. Hours of climbing trees - the descent perhaps a little unsure. A swing suspended where half dazed we sailed - through the air.

FROM A PERCH - on top of the old wall we planned the destiny of the plants. Weeds that were our finest crops, in proud bunches we often picked

A BUNCH FOR YOU

IN SCATTERED DISORDER THE TINY LEAVES and wondrous colours of our ~ favourite plants. FLOWERS OF FANTASY ~ stachys lanata - with leaves like rabbit's ears, fairygloves from foxgloves, mobile faces of snapdragons, fried-egg flowers of limnanthes, perfect fruit of snowberries, bachelors buttons of bright blue cornflowers. Delphiniums that towered above us, seed-heavy heads of marigolds, a hidden primrose, and forget-me-nots that came it seemed ~ from nowhere.

A place to Hide

CONVERSATIONS, for flowers thrive on love ~ and friendly words from those who care.

PETALS ... & RAIN - water we collected to make rare perfumes, that they never wanted to use.

DISCOVERING SCENTS of unknown plants where insects crawled unawares, we watched with curious fascination. Earth we dug for treasure, and the painted fragments of pots our only finds.

AUTUMN BONFIRES of gathered twigs, we had spent the summer whittling & carving into fantastic shapes and where we ate half-cooked potatoes ~

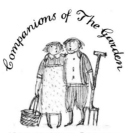

Companions of The Garden

YOU, WHOSE LUPINS
ALWAYS GREW.
AND WAS IT THE EFFECT OF
chance to find your
initials growing~
IN THE FLOWER BED?

SUMMER WAS~
endless days of rasberry
picking, sweet-peas in soft
bunches of muted colours,
small lettuces coming up
in shiny rows, sour apples
we picked too soon, pears
that hung invitingly over
the wall, a mere climb
between us and those
forbidden fruits ~ that
tasted specialy sweet.

SO HO

WEEDING~
PERHAPS WAS NOT ONE OF THE
most exciting tasks, and the

spoils of an overgrown pond
or the thrills of tree felling
~ were a happy distraction.

Pyramids of Pears

PUNNETS OF
strawberries, clusters of red-
currants you turned into
jams and jellies, and the
bitter cherries that were
so disappointing, destined
to a pickled future. When
the days were always warm
and we solved the mystery
of the gooseberry bush.

Round and Round

the
MULBERRY BUSH
chasing our childhood
behind
A Lost Dream.

Freckled Russett Apples~

EARLY MORNINGS
The dew filled lawns dusted
with BAIRNWORT, BABY'S-
PET - the DAISY, before the
heads lay in piles of fresh-
mown grass. A moment of
anguish to find a prized --
flower had found its way
into the daisy-chain.

THE PEE-A-BED
OR DANDELION~
we should not pick.
Buttercups~
held beneath the chin to tell
by the golden reflection~
whether you liked butter.

1
2 3

ONE
TWO
THREE··

~Time for Tea~

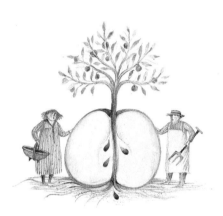

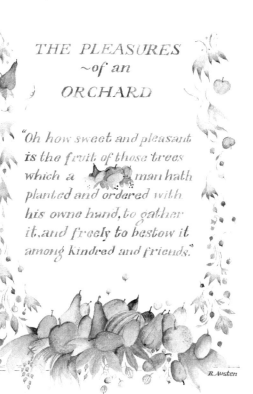

THE PLEASURES
~of an
ORCHARD

"Oh how sweet and pleasant
is the fruit of those trees
which a man hath
planted and ordered with
his owne hand, to gather
it, and freely to bestow it
among kindred and friends."

R. Austen

STRAWBERRY – perhaps so called from the old English word straw – meaning, to cover the ground with scattered things. A fruit of full summer.

PLUM – All plums are under Venus, and are like women – some better and some worse. Culpeper. "A plum year a dumb year"

PEAR – PYRUS communis – so called from their pyramidical shape. "Plant pears for your heirs."

CHERRY – "In countries where there is a great store of cherries, their custom is to eat their breakfasts of Bread, Butter and Cherries"–Austen. "A cherry year a merry year."

CRAB-APPLE – From Siberia and North China. The fruit is small and bad to the taste, but the juice, called verjuice, is used in cooking, for jellys and wine making, also for purifying wax.

FIG – one Greek tradition tells of how the fig tree grew up from the thunderbolt of Jupiter. The first fig trees introduced into England grew in the Archbishop's garden at Lambeth.

ELDERBERRY – An excellent wine made from the berries and the flowers which can be cooked in several ways. As the tree has an unpleasant smell, people ought not to sit in its shade.

APRICOT – So called from 'AFRICUS, meaning– delighting in the sun. Originally from the North of China and thought to be grown in England early in the sixteenth century.

CRANBERRY – So called from its fruit being ripe in the spring, when the crane returns. Also the word CRAN in old English, means red. Grows in peaty bogs.

WHORTLEBERRY or **BILBERRY** – Grows wild on heaths, mountains or in woods. Eaten raw or cooked. Dried leaves used as a tea in Scotland. Also gives a violet coloured dye.

QUINCE – Dedicated by the Ancients to the Goddess of Love, and thus an emblem of love and happiness. Not to be eaten raw, but stewed, or in pies, in tarts with apples is delicious.

BLACKBERRY – belonging to the same tribe as raspberry. Much eaten by children as they gather them wild in hedgerows– but taken in too great quantities, result in unpleasant effects.

CAPE GOOSEBERRY – the fruit inside the lantern shape case can be eaten raw, cooked, or crystallised as a delicacy, and the abandoned cases used for a winter decoration.

ALMOND – 'Phyllis, daughter of Lycurgus, having granted the last favours to Demophoon, son to Theseus, (on condition he marry her on his return) seeing her love tardy, hang'd herself & became an Almond tree.

ORANGE – called so, from the Sanscrit – harange. Saracen brides wore it as a symbol of fecundity, being such a great fruit bearing tree, and this tradition has been passed down.

GRAPE – An old Rabbinical tale says Adam planted the vine, and the Devil buried at its roots a lamb, a pig and a lion. So those that drink too much of the juice become fierce, feeble or hoggish.

MEDLAR – "You'll be rotten ere you be half ripe, and that's the right virtue of the medlar"– Shakespeare.

COWBERRY or **RED WHORTLEBERRY** – though not of a very grateful flavour, are used in tarts, juices and pies, especially gathered by country folk in early 19th century, when pies were popular.

NECTARINE – Owing to its fragrant taste, it is called the 'drink of the Gods.' Like a peach without its fur-coat.

LOGANBERRY – named after the American – Judge James Logan who first produced it in 1881 in California.

HOP – The dried flower-buds of a beautiful plant, which native to England grows twining round poles or hedges. The Dutch first used it in beer in the 14th century, and brought it here. Henry VIII forbade its use in Ale.

SLOE – The fruit of the blackthorn, a small wild plum. "When you fell your underwoods sow haws and sloes in them, and they will furnish you, without doing of your woods any hurt."

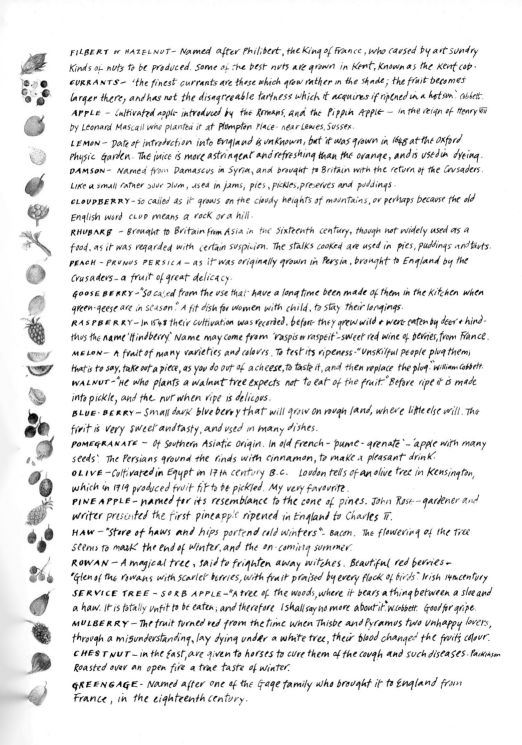

FILBERT or **HAZELNUT** – Named after Philibert, the King of France, who caused by art sundry kinds of nuts to be produced. Some of the best nuts are grown in Kent, known as the Kent cob.

CURRANTS – 'the finest currants are those which grow rather in the shade; the fruit becomes larger there, and has not the disagreeable tartness which it acquires if ripened in a hot sun'. Cobbett.

APPLE – Cultivated apple introduced by the Romans, and the Pippin Apple – in the reign of Henry VIII by Leonard Mascall who planted it at Plumpton Place – near Lewes, Sussex.

LEMON – Date of introduction into England is unknown, but it was grown in 1648 at the Oxford Physic Garden. The juice is more astringent and refreshing than the orange, and is used in dyeing.

DAMSON – Named from Damascus in Syria, and brought to Britain with the return of the Crusaders. Like a small rather sour plum, used in jams, pies, pickles, preserves and puddings.

CLOUDBERRY – So called as it grows on the cloudy heights of mountains, or perhaps because the old English word CLUD means a rock or a hill.

RHUBARB – Brought to Britain from Asia in the sixteenth century, though not widely used as a food, as it was regarded with certain suspicion. The stalks cooked are used in pies, puddings and tarts.

PEACH – PRUNUS PERSICA – as it was originally grown in Persia, brought to England by the Crusaders – a fruit of great delicacy.

GOOSEBERRY – "So called from the use that have a long time been made of them in the Kitchen when green-geese are in season." A fit dish for women with child, to stay their longings.

RASPBERRY – In 1548 their cultivation was recorded, before they grew wild & were eaten by deer & hind – thus the name 'Hindberry'. Name may come from 'raspis or raspeit' – sweet red wine of berries, from France.

MELON – A fruit of many varieties and colours. To test its ripeness – "Unskilful people plug them; that is to say, take out a piece, as you do out of a cheese, to taste it, and then replace the plug." William Cobbett.

WALNUT – "He who plants a walnut tree expects not to eat of the fruit." Before ripe it is made into pickle, and the nut when ripe is delicious.

BLUE-BERRY – Small dark blue berry that will grow on rough land, where little else will. The fruit is very sweet and tasty, and used in many dishes.

POMEGRANATE – Of Southern Asiatic origin. In old French – 'pume-grenate' – 'apple with many seeds'. The Persians ground the rinds with cinnamon, to make a pleasant drink.

OLIVE – Cultivated in Egypt in 17th century B.C. Loudon tells of an olive tree in Kensington, which in 1719 produced fruit fit to be pickled. My very favourite.

PINEAPPLE – named for its resemblance to the cone of pines. John Rose – gardener and writer presented the first pineapple ripened in England to Charles II.

HAW – "Store of haws and hips portend cold winters" – Bacon. The flowering of the tree seems to mark the end of winter, and the on-coming summer.

ROWAN – A magical tree, said to frighten away witches. Beautiful red berries – "Glen of the rowans with scarlet berries, with fruit praised by every flock of birds." Irish 14th century.

SERVICE TREE – **SORB APPLE** – "A tree of the woods, where it bears a thing between a sloe and a haw. It is totally unfit to be eaten; and therefore I shall say no more about it." W. Cobbett. Good for gripe.

MULBERRY – The fruit turned red from the time when Thisbe and Pyramus two unhappy lovers, through a misunderstanding, lay dying under a white tree, their blood changed the fruit's colour.

CHESTNUT – in the East, are given to horses to cure them of the cough and such diseases. Parkinson. Roasted over an open fire a true taste of winter.

GREENGAGE – Named after one of the Gage family who brought it to England from France, in the eighteenth century.

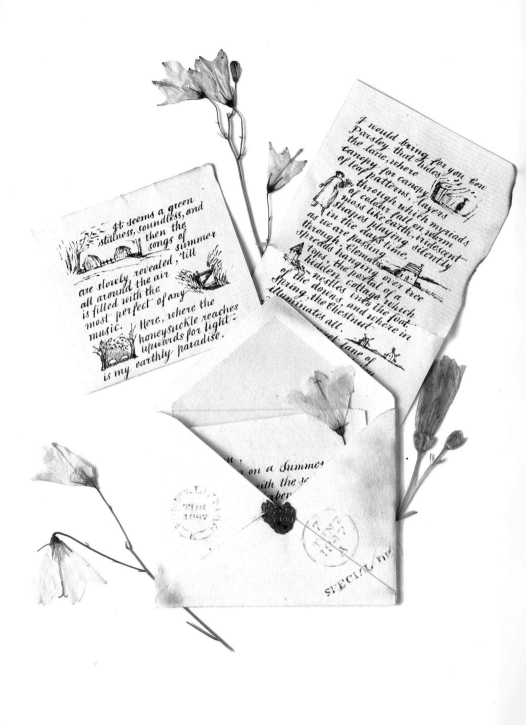

It seems a green stillness, soundless, and then the songs of summer are slowly revealed, 'till all around the air is filled with the most perfect of any music. Here, where the honeysuckle reaches upwards for light, is my earthly paradise.

I would bring for you, too, Parsley, that hides the lane, where canopy for canopy, layers of leaf patterns, players through which fall on myriads of colour, iridescent moss like earth, warm shapes like earth, silently in the days time, as we are passing playing, through Clematis, over tree shreds hanging, hidden cottage of a tops, the portal of a of the downs, and where in nestles into the foot Spring, the Chestnut illuminates all.

...on a Summer
...with the so...
...ber

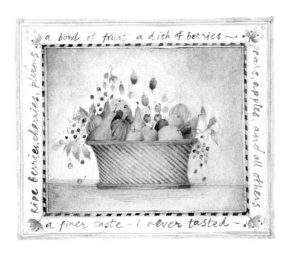

a bowl of fruit a dish of berries ~

ripe berries, cherries, plums

pears, apples, and all others

a finer taste ~ I never tasted ~

of Gathering and Keeping Fruit

"Although it be an easie matter, when God
shall send it to gather and keep fruit, yet
are there certain things worthy your regard:
you must gather your fruit when it is ripe
and not before, else it will wither and be
tough and sour. All fruits generally are ripe
when they begin to fall: For trees do as all
other bearers do, when their young ones are
ripe, they will wain them. The dove her
pidgeons, the Coney her Rabbets, and women
their children". William Lawson

TOPIARY

BEHIND GREEN CLIPPED HEDGES TOWER THE SHAPES OF THE FANTASY GARDEN, WHERE SINCE ROMAN TIMES MAN HAS USED NATURE TO FIT HIS IMAGINATION. IN THIS PLAY~GROUND OF BOX, YEW, HOLLY AND BAY, DREAMS ARE DEFINED.

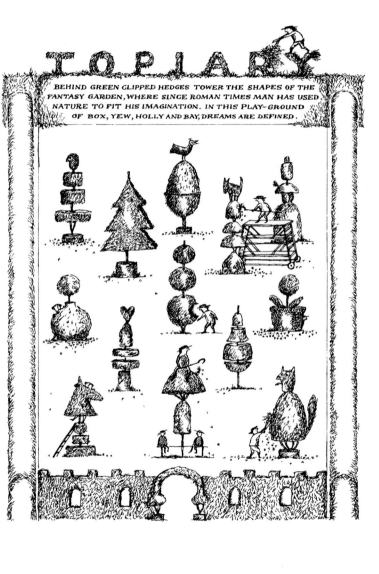

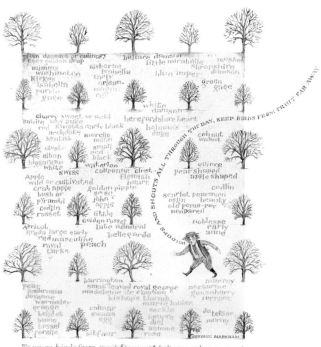

plum damson or culinary
gees golden drop
nimms
washington
Kirkes
isabella
purple
gage

gisborne
isabella
early
orlean
magnum
bonum

bullace damson
little mirabelle
russel
Shropshire
blue imper. damson

green
gage

white
damson

cherry sweet or acid
londre may duke
red Knights early black
archduke morello
Kentish main
cluster small
elton red
biggareau black
white swiss waterloo
flemish
heart

herefordshire heart
helmans
duke

cob nut
walnut

quince
pear shaped
apple shaped

Apple
wild or cultivated
crab apple
bush or
pyramid
codlin
russet

colbenne
golden pippin
or st
john
apple
little
golden russet

codlin

scarlet, pearmain
oslin beauty
old pome-roy
nonpareil

Apricot
brada large early
red masculine
royal
turkey

late admiral
bellegarde
peach

noblesse
early
anne

Pear
ambrosia
downe
wormsley
orange
bellé et
bonne
hessel
forelle

barrington
small leaved royal george
madeleine de courson
bishops thumb
colmar
swans
egg
pilfour

seckle
beurre
diel
sotame
rose

murray
nectarine
gooseberry
currant

maria louise
du tellier
murray

SERVASSE MARKHAM

WHOOPS AND SHOUTS ALL THROUGH THE DAY, KEEP BIRDS FROM FRUIT FAR AWAY

To scare birds from fruit. "You must take some boy or young
fellow that must every morning from the dawning of the
day till the sunne be more than an hour high, and every
evening from five of the clock till nine, runne up and down
your ground whooping, shouting & making a great noise."

"I could highly commend your orchard, if either through it or hard by it – there could run a pleasant River with silver streams; you might sit in your mount, and angle a peckled trout, sleighty eel or some other dainte Fish".
Lawson

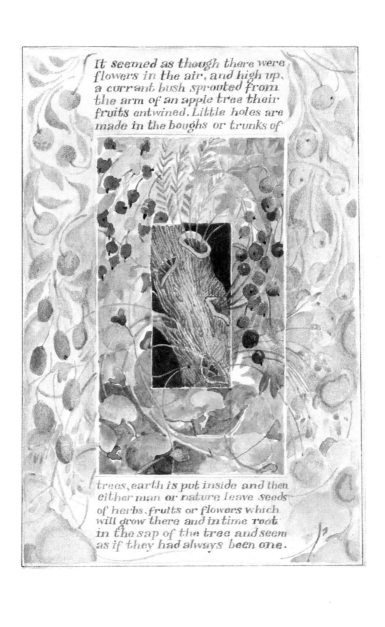

It seemed as though there were
flowers in the air, and high up,
a currant bush sprouted from
the arm of an apple tree their
fruits entwined. Little holes are
made in the boughs or trunks of

trees, earth is put inside and then
either man or nature leave seeds
of herbs, fruits or flowers which
will grow there and in time root
in the sap of the tree and seem
as if they had always been one.

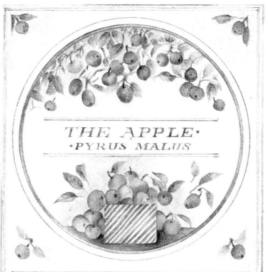

THE APPLE·
·PYRUS MALUS

"*in most mens houses of account, where, if there grow any rare or excellent fruit, it is then set forth to be seene and tasted.*"

A Most Favourite Fruit

FOR PIES, tarts, puddings, sweets, sauces
· · · · · ·ONE third of boiled apple pulp, baked
with two thirds of flour, having been properly
fermented with yeast for twelve hours, makes
a very excellent bread, and extremely light
and palatable.
· · · · · · THE fermented juice forms cider.
IN CONFECTIONARY · · it is used for
comfits, marmalades, jellies and pastes.
IN DYEING, the bark produces a yellow
colour.
THE WOOD is firm, hard, and compact;
hence used for turning. *Mr. Ellman.*

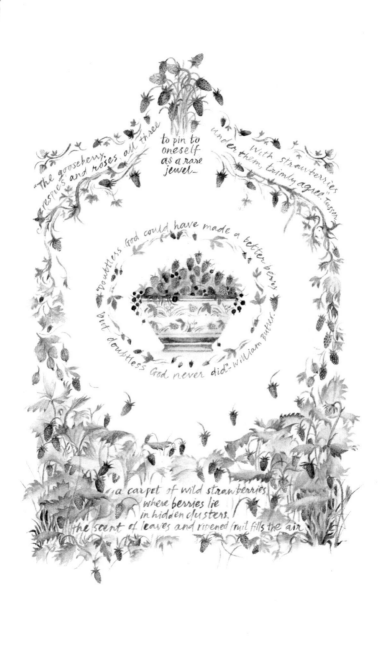

"The gooseberry, respies and roses, all three under them, trimly agree." Tusser. with strawberries to pin to oneself as a rare jewel.

"Doubtless God could have made a better berry, but doubtless God never did." William Butler.

...a carpet of wild strawberries,
where berries lie
in hidden clusters,
the scent of leaves and ripened fruit fills the air.

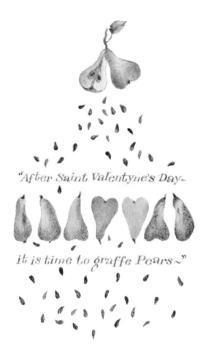

"After Saint Valentyne's Day~

it is time to graffe Pears~"

TO PICK A PERFECT PEAR ~

1: A POT OF PEARS

4: PIECES OF PEAR

2: A PAIR OF PEARS

5: PLACED ON A PLATE

3: TO PEEL AND PARE
A PLUMP RIPE PEAR

6: AND SO PARTAKE OF
THE PLEASING PORTION

A jug of rosewater in your room
a most refreshing and sweet lotion
with which to wash. Made from~

If red petals are used~
they give pink~water.

brown water is yielded
from yellow rose petals.

a pound of scented rose petals~
covered with water, simmered for
about ten minutes, and strained.

to preserve plums whole

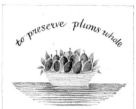

'dip stalks and leaves in
boiling vinegar, scald the
fruit and remove their
skin with a pin, boil the
sugar to a candy height,
dip in your plums, then
hang them by the stalks
to dry finely transparent.'

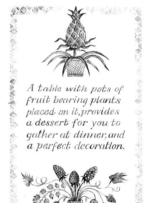

A table with pots of
fruit bearing plants
placed on it, provides
a dessert for you to
gather at dinner, and
a perfect decoration.

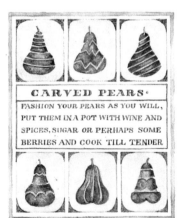

CARVED PEARS.
FASHION YOUR PEARS AS YOU WILL,
PUT THEM IN A POT WITH WINE AND
SPICES, SUGAR OR PERHAPS SOME
BERRIES AND COOK TILL TENDER

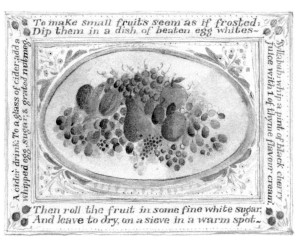

To make small fruits seem as if frosted:
Dip them in a dish of beaten egg whites~

A cider drink: To a glass of cider add a whipped egg, sugar, & grated nutmeg.

Syllabub: whip a pint of black cherry juice with 1 of thyme flavour cream.

Then roll the fruit in some fine white sugar,
And leave to dry, on a sieve in a warm spot~

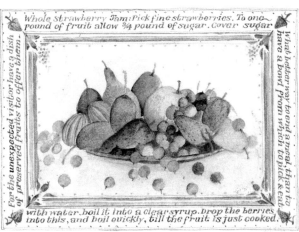

Whole Strawberry Jam: Pick fine strawberries. To one pound of fruit allow ¾ pound of sugar. Cover sugar

For the unexpected visitor have a dish of preserved fruits to offer them.

What better way to end a meal, than to have a bowl from which to pick & eat.

with water, boil it into a clear syrup. Drop the berries into this, and boil quickly, till the fruit is just cooked.

"You who employ your time to
cultivate your Gardens, and
to make their Glory great—
Among your Groves and flowers
let Water flow, Waters the soul
of Groves and flowers too". Rapinus.

It was one of those late summer days, when the sun
surprises and delights us, that we sat on the wooden
bridge spanning the six feet of stream just below the
springhead. The water was perfectly clear, waving
through cress as it so gently flowed into the pond,
from where it cascaded under the mill. We must
have disturbed a coot, who vanished into the
rushes on the island. The sand was soft underfoot,
a golden bank of light and the waves of swaying
water-cress sprang up defiantly. From the grass
slopes we reached to pick the cress, eating it, as we
cupped our hands and drank of the sweetest water.
It was here early in the year we had watched the
plump trout spawning, and with the vibration of
our steps, they rose, startled, stirring the sands as
they darted off in search of another sun-beam
under which to lie, thought unseen, but seen by me.

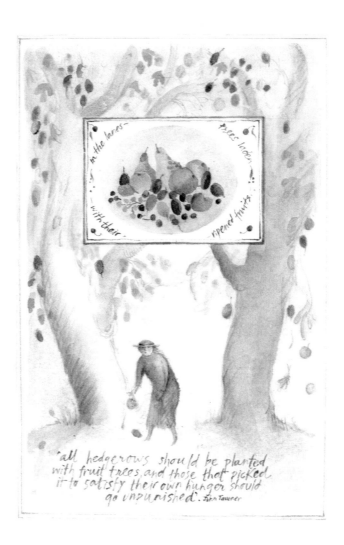

in the lanes— trees laden with their ripened fruits.

'all hedgerows should be planted
with fruit trees, and those that picked
it to satisfy their own hunger should
go unpunished'. John Tavener

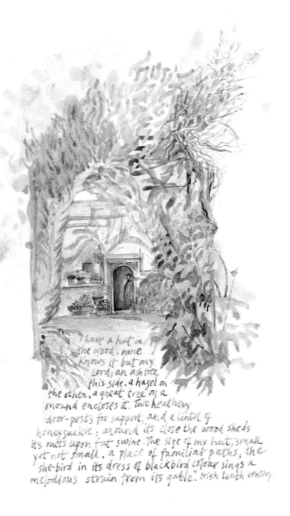

"I have a hut in
the wood, none
knows it but my
Lord; an ash tree
this side, a hazel on
the other, a great tree on a
mound encloses it. Two heathery
door-posts for support, and a lintel of
honeysuckle; around its close the wood sheds
its nuts upon fat swine. The size of my hut; small
yet not small, a place of familiar paths, the
she-bird in its dress of blackbird colour sings a
melodious strain from its gable". Irish tenth century.

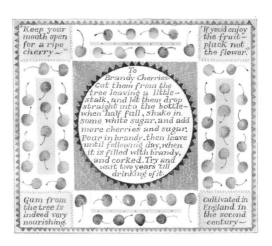

'Keep your mouth open for a ripe cherry~'

If youd enjoy the fruit~ pluck not the flower'.

To Brandy Cherries. Cut them from the tree leaving a little stalk, and let them drop straight into the bottle~ when half full, shake in some white sugar, and add more cherries and sugar. Pour in brandy, then leave until following day, when it is filled with brandy, and corked. Try and wait two years 'till drinking of it.

Gum from the tree is indeed very nourishing.

Cultivated in England in the second ~century~

'Did God or man make plums from sloes?
The truth may be, that no-one knows.
How blessed are we when summer comes
To celebrate this feast of plums—'

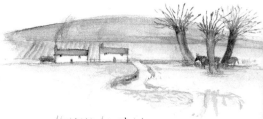

beyond the garden gate -
The frozen fields of winter, even
more beautiful covered with
mystery in the half light
of evening

Heavenly sights
like dreams created - they come
on nights like these. The scent
of wood fires that fills the mind
with distant memories.
And quietly, the woods
have renewed themselves.

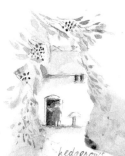

delights of finding first
spring flowers - the snowdrop
comes as messenger for - primrose,
aconite, and those that
pass underfoot so
massed we cannot
see each alone.
"spring is here when
you can tread on 9 daisies
at once, on the village green".

the black-berry.
pickers.

hedgerows
that bind the
lane, filled with dog-rose,
blackberries, nettles, sloes, and
elder - fruit and berries for
drinks and dishes.

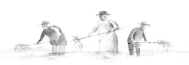

the diggy smell of fresh
cut hay, the summer
song as the
mowers sway, voices rising into midday-air.

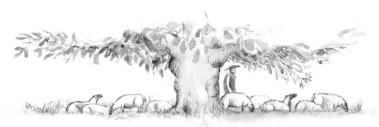

"You may shear your sheep when the elder blossoms peep."
Afternoons at garden fêtes, flowered hats, tables
laden with home produce, jams, cakes and
such tempting offerings. and from
the cows — continuously chewing —
milk for teas, and cream for
scones.

"A field requires three things —
fair weather, sound seed, and a
good husbandman."

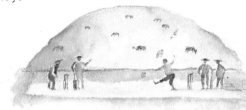

In the shadow of the Downs — we
watched the half play of
cricketers in the magic of the early
evening. as the corn moves in moiré
patterns within its field, the lights
and darks of ripening growth.
across the fields at close of day —

they come with much rejoicing.
bearing the last load of
harvest as another season
turns down.

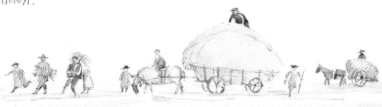

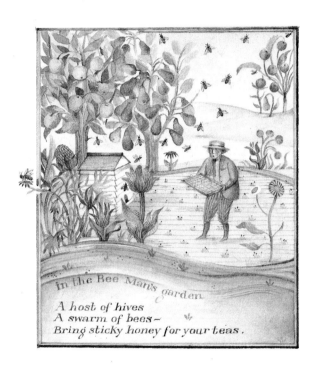

In the Bee Man's garden

A host of hives
A swarm of bees ~
Bring sticky honey for your teas.

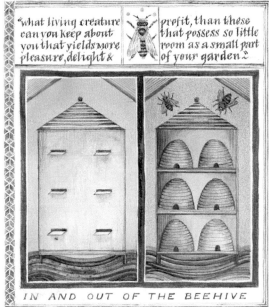

"what living creature can you keep about you that yields more pleasure, delight & profit, than these that possess so little room as a small part of your garden"

IN AND OUT OF THE BEEHIVE

...lay 'tis your bees and you will not note none but their they are then provoked and fill your garden with their ... and treasure... prying of they ... frees from sweet smell to flowers...

"Prone to revenge, the bees, a wrathful race,
When once provoked, assault the aggressor's face:
their latent slings an easy passage find,
and wounding, leave their foolish souls behind."

A sweet scented path of thyme, most beloved
of bee flowers, may lead to the hives set in
the midst of a garden or grassy orchard,
and round about it, both for the bee's
happiness and to increase the yield of
honey, grow those plants which bees
particularly delight in. For early flowering;
crocus, butter-bur, hepatica and black-hellebore.
Those of sweetest savour: savory, smallage, sage,
violets, lavender, sweet marjoram, saffron, poppies,
balm, beans, mustard-seed, melilot, forget-me-not
roses, clovers, hollyhock, honeysuckle, mignonette,
catmint, sunflower, arabis, borage, vetch, marsh-
mallow, bell-flowers, heather, broom, and 'bee
flower,' the old name for the wallflower; as it
is especialy sweet to bees. Of fruit trees and
 fruiting plants they most delight in are;
 the apple, cherry, almond, peach, pear,
 raspberries, strawberries, and goose-
 berries which are valuable as they
 flower early. Pine, willow, lime and fir are
 the trees they prefer. Holly and gorse
 would provide a shelter from strong
winds. If the hives are rubbed with balm or
sweet cicely, this would please the bees even
more. But – perchance you should be caught
unawares in the bee-garden, then
~ a leaf of either dock, mallow,
 rue hollyhock or ivy, which may
 happen to be growing close at
hand, should be rubbed on the sting
in the hope it will help bring relief.

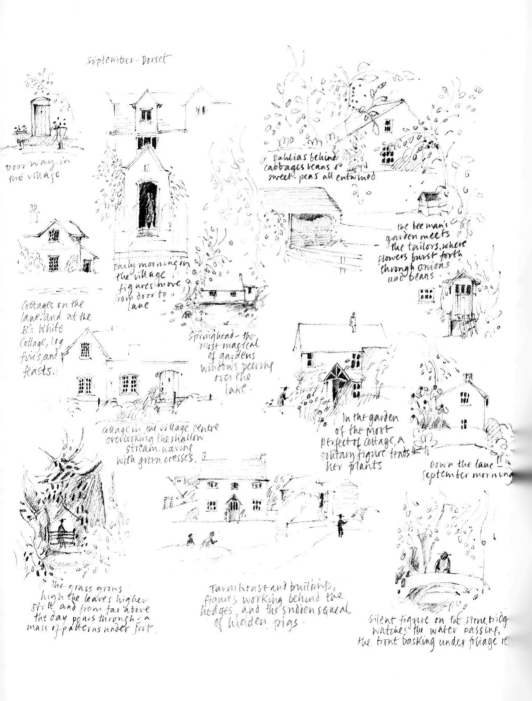

September - Dorset

Doorway in the village

Early morning in the village figures move from door to lane

Cottages on the lane, and at the B's White Cottage, log fires, and feasts.

dahlias behind cabbages beans & sweet peas all entwined

the bee man's garden meets the tailors, where flowers burst forth through onions and beans

Springhead - the most magical of gardens, windows peering over the lake.

cottage in the village centre overlooking the shallow stream, waving with green cresses.

In the garden of the most perfect of cottages, a solitary figure tends her plants

down the lane september morning

The grass grows high, the leaves higher still, and from far above the day pours through - a mass of patterns under foot.

Farmhouse and buildings, figures working behind the hedges, and the sudden squeal of hidden pigs.

silent figure on the stone bridge watches the water passing, the trout basking under foliage r...

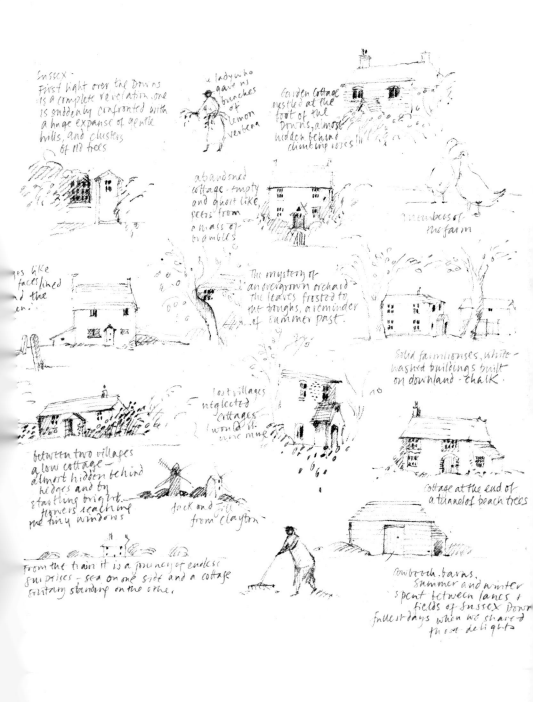

Sussex.
First light over the Downs
is a complete revelation. One
is suddenly confronted with
a huge expanse of gentle
hills, and clusters
of old trees

a lady who
gave us
bunches
of
lemon
verbena

Garden Cottage
nestled at the
foot of the
Downs, almost
hidden behind
climbing roses

abandoned
cottage - empty
and ghost like,
peers from
a mass of
brambles

members of
the farm

...s like
faces lined
...d the
...n.

The mystery of
an overgrown orchard
the leaves frosted to
the boughs, a reminder
of summer past.

Solid farmhouses, white-
washed buildings built
on downland - chalk.

lost villages
neglected
cottages
I would
... mine

between two villages
a low cottage —
almost hidden behind
hedges and by
startling bright
flowers reaching
the tiny windows

Jack and Jill
from Clayton

cottage at the end of
a tunnel of beach trees

From the train it is a journey of endless
surprises – sea on one side and a cottage
solitary standing on the other.

Cowbeech. barns.
summer and winter
spent between lanes &
fields of Sussex Down
fullest days when we shared
these delights

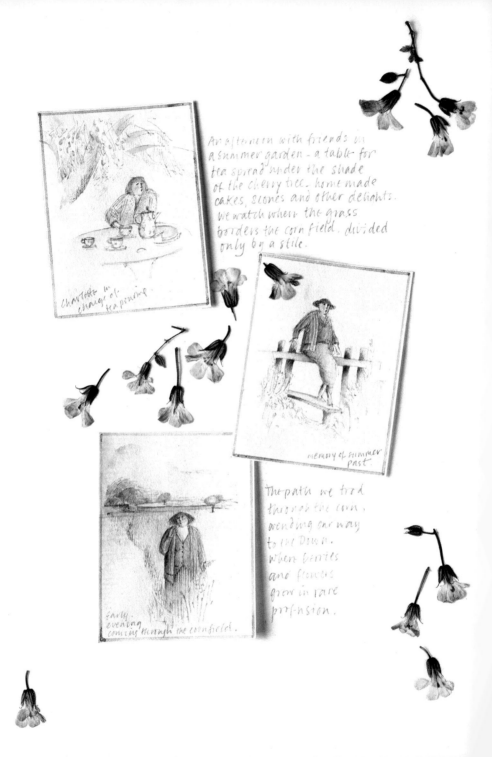

An afternoon with friends in a summer garden - a table for tea spread under the shade of the cherry tree. home made cakes, scones and other delights. We watch where the grass borders the corn field. divided only by a stile.

Charlotte in charge of tea pouring

memory of summer past.

The path we trod through the corn. wending our way to the Down. where berries and flowers grow in rare profusion.

Early evening coming through the cornfield.

Some of us, played croquet
after lunch, barefoot on
the grass. in two teams,
we ravaged the lawn
with concentrated
determination. The
cracks of mallets against
balls so clear — impossible
to cheat.

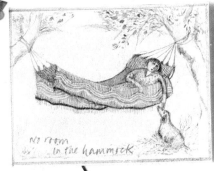

No room
in the hammock

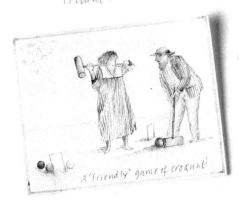

A 'friendly' game of croquet

under
shady
summer
trees —
we often
sat and
dreamt.

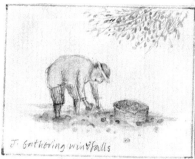

J. Gathering windfalls

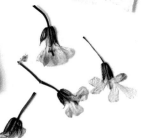

One chief grace that adornes an orchard I cannot let slippe: A broode of Nightingales, who with their several notes and tunes, with a strong delight-some voyce, out of a weake body, will beare you company night and day. She will help you to cleanse your trees of Caterpillars, and all noysome wormes and flyes. The gentle Robbin-red-brest will helpe her, and in winter the coldest stormes will keepe a part. Neither will the silly wren be behind in Summer, with her distinct whistle (like a sweet Recorder) to chear your spirits.

The Black-bird and Throstle (for I take it, the Thrush sings not, but devours) sing loudly in a May morning, and delights the ear much, and you need not want their company, if you have ripe Cherries or Berries, and would as gladly as the rest do your pleasure: but I had rather want their company than my fruit. What shall I say? A thousand of pleasant delights are attending an Orchard: and sooner shall I be weary, than I can reckon the least part of that pleasure, which one that hath, and loves an orchard, may find therein. What is there of all these few that I have reckoned, which do not pleasure the eye, the ear, the smell and taste? And by the senses, as Organs, Pipes and Windows, these delights are carried to refresh the gentle, generous and noble mind...' William Lawson.

'A thousand of pleasant delights are attending an orchard'

if you
would build
a house,
place
it in
the
midst
of an
orchard

so as
you may
exercise
within the
orchard: set
a bowling alley
between the rows
of fruit trees.

Grass
walks by
shaped hedges
with windows so cut
that we may peep onto
those orchard views.

In the orchard
turf, spring bulbs
are naturalised, and
climbing plants
adorn the trees.

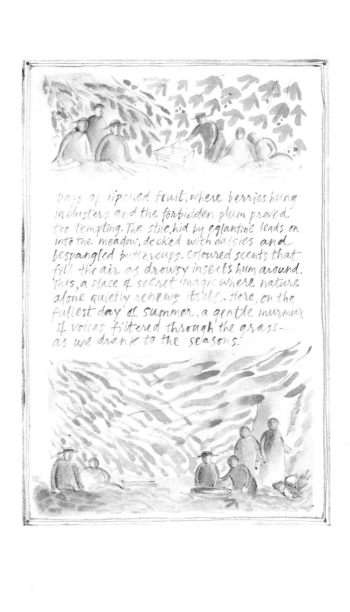

Days of ripened fruit, where berries hung
in clusters and the forbidden plum proved
too tempting. The stile, hid by eglantine leads on
into the meadow, decked with daisies and
bespangled buttercups. Coloured scents that
fill the air as drowsy insects hum around.
This, a place of secret magic where nature
alone quietly renews itself. Here, on the
fullest day of summer, a gentle murmur
if voices filtered through the grass—
as we drank to the seasons.

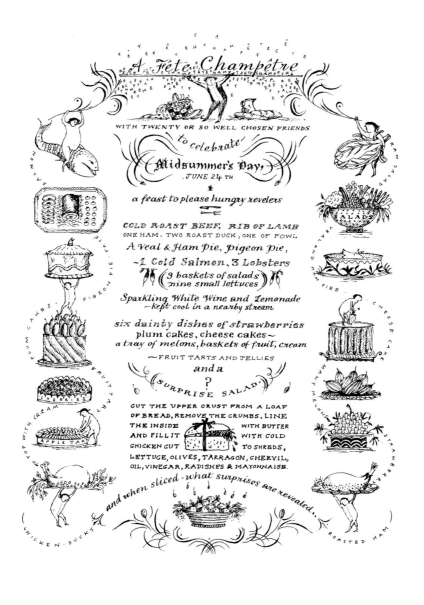

A Fête Champêtre

WITH TWENTY OR SO WELL CHOSEN FRIENDS

to celebrate

Midsummer's Day,
JUNE 24 TH

a feast to please hungry revelers

COLD ROAST BEEF, RIB OF LAMB
ONE HAM. TWO ROAST DUCK, ONE OF FOWL

A Veal & Ham Pie, Pigeon Pie,

~1 Cold Salmon, 3 Lobsters

3 baskets of salads
nine small lettuces

Sparkling White Wine and Lemonade
~kept cool in a nearby stream

six dainty dishes of strawberries
plum cakes, cheese cakes~
a tray of melons, baskets of fruit, cream

~FRUIT TARTS AND JELLIES
and a

SURPRISE SALAD

CUT THE UPPER CRUST FROM A LOAF
OF BREAD, REMOVE THE CRUMBS. LINE
THE INSIDE WITH BUTTER
AND FILL IT WITH COLD
CHICKEN CUT TO SHREDS,
LETTUCE, OLIVES, TARRAGON, CHERVIL,
OIL, VINEGAR, RADISHES & MAYONNAISE.

and when sliced · what surprises are revealed..

SALAD

SALMON

CREAM SALAD

PIGEON PIE · PÂTÉ

PLUM CAKES

HAM PIES

FRUIT TART

CHERRIES

CHEESE CAKE

MANY MELONS

APPLE TART

TOP WITH CREAM

CHICKEN · DUCKS

STRAWBERRY

ROASTED HAM

PHILIP MILLER

"ESPALIERS~ ARE COMMONLY **PLANTED TO SURROUND**
THE QUARTERS OF KITCHEN GARDENS IN WHICH PLACE
THEY HAVE A VERY GOOD EFFECT, IF RIGHTLY PLANTED
AND MANAGED, RENDERING IT NOT IN THE LEAST BIT
INFERIOR TO THE FINEST PARTERRE OR THE MOST
FINISHED PLEASURE GARDEN : FOR WHAT CAN BE MORE
AGREEABLE THAN TO WALK BETWEEN REGULAR HEDGES
OF FRUIT TREES, WHICH EARLY IN THE SPRING ARE
COVERED WITH BEAUTIFUL FLOWERS AND IN SUMMER
AND AUTUMN, ARE CHARGED WITH NOBLE FRUITS
OF DIFFERENT KINDS; AND THE KITCHEN STUFF IN
THE QUARTERS ARE ENTIRELY HID FROM SIGHT &
ALSO SCREENED FROM THE INJURIES OF WEATHER?"

~*divers ways of training your fruit trees*~

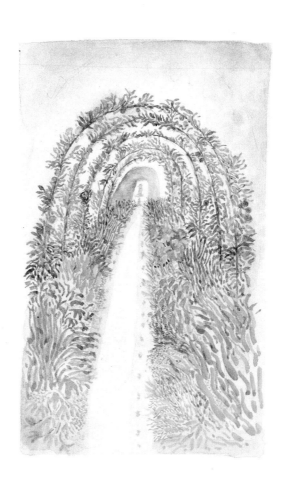

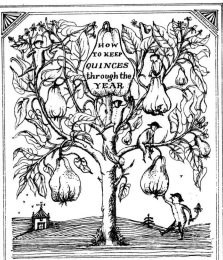

HOW
TO KEEP
QUINCES
through the
YEAR

THE QUINCE was greatly valued for its
fruit and flowers, the latter being an
important part of the most favoured
complexion-creams. Dishes of the fruit
cooked in various ways were served as
desserts, and some preserved quinces-
shared amongst friends when thus
prepared: "Cut them into small pieces,
boil them in a quart of water, to which
one spoon of salt and same of honey is
added, until the water tastes strongly
of quince, and add a quart of white-
wine vinegar. Lay the quinces at the
bottom of an earthenware jar, pour
the above liquor over them, and then
secure the mouth of the vessel closely."

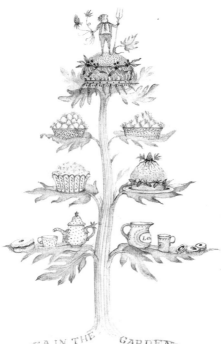

TEA IN THE GARDEN
to be taken at four, if the sun does shine
—and the rain doesn't pour, Cucumber sandwiches
sliced like a dream, brown boiled eggs then
cowslip cream, Strawberry ice and fresh
lemonade, pale china tea all out in the
shade. And if there's room, do not
forsake at least one slice
of home made cake.

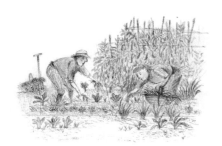

THE GARDEN
of
HERBS

"oft digging removing and
weeding yee see makes
hearbs the more whole—
some and greater to be."

T. TUSSER

CHIVES - A favourite herb to chop into salads, soups, cheeses, sandwiches and a great variety of dishes. If it is left to flower, the pink heads and slender stems are a decorative edging plant.

BERGAMOT - The red flowers floating in drinks or scattered on salads add a joyful colour to summer dishes, but must first be well searched for earwigs that often live herein.

SWEET CICELY - One of the first herbs to appear after the winter season and with its fern-like leaves is lovely in a garden. In the 16th century the roots were boiled like parsnips and then dressed.

PURSLANE - Yellow or green, the succulent leaves and stems make a tasty salad with cucumber tomatoes, herbs, onions + vinaigrette, or pickled as it was in the Middle Ages, when brought here.

PENNYROYAL - Mentha Pulegium - the Latin name from PULEX a flea - for it was meant to keep fleas away. It was known as Pudding Grasse for it was put with puddings and meats.

BETONY - Prized for its use as an amulet in Saxon days, as a protection against wicked spirits. Betony tea calms the nerves and relieves headaches.

MALLOW - Chervil, Dill and Coriander grow happily together and look good as they flower at the same time. It was used medicinaly, its Latin name Althaea is from the Greek 'to cure.'

DILL - First grown in England in 1597. From the Saxon 'Dillan', meaning to lull, as its seeds were used to soothe babies to sleep. As a tisane it helps stop hiccoughs.

CORIANDER - From the Greek 'Koris' - bed-bug, as it smells of insects. One of the bitter herbs that was said to have been eaten at the Passover.

SAFFRON - A highly prized herb, and the only one to have a town named after it - 'Saffron-Walden', where it once was extensively grown. The use of it made the English sprightly. Bacon.

ANISE - A native of the Middle East and one of the oldest spices, it is mentioned in the bible. Aniseed balls - a favourite sweet for children. Used in liqueurs, and flavouring.

BORAGE - 'Always brings courage.' In Elizabethan days both the hairy leaves, and blue flowers were used in salads. They are a pleasant decoration floating in cool summer drinks.

CARAWAY - derives its name from 'Karawiya', the Ancient Arabic word for its seed, when it was used for medicinal and flavouring purposes. Add seeds to cakes, soup, bread and cheeses.

MARIGOLD - The dried or fresh petals when added to soup or rice give off a golden colour, thus it serves as a substitute for saffron. Its Latin name 'calendula', for it is meant to flower each month.

VIOLET - A favourite flower since Ancient times. A symbol of constancy. The Romans drank violet wine, + in Tudor times syrups, teas, conserves and honey were made with it.

BOG MYRTLE - Found growing in bogs and wet heathlands. Leaves were formerly used in flavouring beer. A little amount of it can be used in meat stews. It also keeps away fleas.

ALECOST or COSTMARY - 'This inhabitant in every garden is well known', Culpeper wrote in the 16th century, when it was used to spice beer. Hence the name - 'costis' - herb with spicy flavour.

CLARY - or 'clear eye', for an eye bath of the seeds when soaked in water, clears the eye of grit. The leaves are used in flavouring wines and other drinks

SOAPWORT - Used as a natural soap for all washing purposes, as far back as Roman days. Steeped in boiling water, with chamomile flowers, it makes a good shampoo.

MEADOWSWEET - A favourite strewing herb. Also called 'Bride-Wort', as it was custom to strew it at wedding celebrations. 'The floures boiled in wine + drunke, make the heart merrie' Gerard.

ROSE - 'Among all floures of the worlde, the floure of the rose is cheyf and beeryth ye pryse. And by cause of vertues and swete smelle and savsur.' Bartholomeaeus Anglicus 1480

LEMON VERBENA - In scented bunches it refreshes any room, and dried should be put in pot-pourris and sachets. Lovely to have growing by the window, so scents float in.

GOOD KING HENRY - or Fat Hen, Eaten since Neolithic times. Young leaves in spring are eaten as a green vegetable, and the shoots peeled and eaten like asparagus.

WORMWOOD or ARTEMESIA - its name comes from Artemis, the Greek Goddess of Beauty, who appreciated it so much that she gave it her name. Used in Absinthe & Vermouth.

WOODRUFF - When dried it smells of new mown hay, and so it became a favourite sweet-herb. Hung in rooms, to scent them, and both the flowers and leaves used for tisanes.

PARSLEY - Eaten after leeks, onions or garlic will take away their offending smell. 'It takes an honest man to grow parsley well.'

GARLIC - has a well known odor especially powerful at midday. The want of garlic was lamented to Moses by the Israelites when in the wilderness.

SAVORY - Introduced by the Romans. Winter Savory - a perennial. Summer Savory - an annual - good sprinkled on broad beans & butter. Both used in flavouring, & against bee-stings.

CAMOMILE - A herb used for strewing on floors, to scent Elizabethan rooms. Used as a tea it cures many ailments. Peter Rabbit's Mother gave him a dose at bed-time when he was ill.

FENNEL - 'The green leaves be stuft in sea-fish to take away their sea savour and smell in eating, which the daintie can scarcely abide' Thomas Hyll

COMFREY - or 'Knit-bone', for the leaves when applied as a poultice to swelling & sprains, would effect a remedy. The pounded root was used like a plaster in treating bone-fractures.

MUSTARD - The Romans used mustard as a condiment, and made a sauce of it by pounding the seeds with wine. In England it was ground into balls with honey & cinnamon.

TANSY - 'The seed is much commended against all sorts of worms in children. The young leaves, shred with other herbs were beaten with eggs and fryed into cakes - called TANSIES.

VERVAIN - A sacred herb of the Druids. 'If the dining room be sprinkled with water in which the herbe hath been steeped the guests will be the merrier'. Pliny

MANDRAKE - with magical and medicinal connections. A man pulling it from the ground would be killed, so dogs were tied to it and when they lifted it from the soil they died instead.

THYME - 'To lie on a warm bed of South Down thyme is to understand how the ultimate compliment paid by the Greeks to an author, was that his verse smelt of thyme' Woodward

TARRAGON - For vinegar - cut it when the weather is dry & before it flowers. Put 2 ounces of leaves & stalks in a bottle of 2 quarts of vinegar. Cork and leave for 2 weeks. Strain & re-bottle.

COWSLIP - One of the loveliest of spring flowers it used to be found growing profusely in meadows, and was used in the making of salads, creams, wines, lotions and many dishes.

SOUTHERNWOOD - thought of as an aphrodisiac it also used to be called 'Lad's Love'. The French called it 'Garde Robe' as its strong smell kept moths away from clothes.

SAMPHIRE - 'You cannot provide too much of this excellent ingredient in all crude sallads' - John Evelyn. Grows in certain British coastal areas. Eaten pickled or fresh.

SUNFLOWER - The outsize plants that grow in cottage gardens, and flowers that fill acre upon acre of yellow fields. Seeds are good for goats, poultry and pigs, & yield a good salad oil.

PELARGONIUM or GERANIUM - that line the window-sills with a great variety of sweet smells and bright flowers. Leaves can be put in salads & pot pourris. Oil used in perfumery.

JASMINE - Whose star like flowers fill the evening air with rich scents. Though it has Eastern Associations, it has grown here for centuries. Elizabethans made perfume from it.

LIME - Trees that shade avenues and lead to the market at Buis-les-Baronnies, where in July most of France's 'Tilleul' changes hands - for the dried flowers make a very good tea.

SEEDS AND HERBS FOR KITCHEN USE~
BETONIE BUGLOS BLOODWORT BEETS
BURNET BURRAGE COLEWORT
CHERVIL CLARIE CABAGE
ENDIVE FENNEL TIME
MALLOWS LETTIS'
MARIGOLDS'
PARSLEY
NEPS

LONGWORT ONION PATIENCE PENNYROYAL SAGE
MINT PRIMROSE ROSEMARIE ENGLISH
SAFFRON SUMMER-SAVORIE TANSIE
SPINAGE SUCKERIE VIOLETS OF
ALL SORTS HORSE-RADISH
CARRAWAY PURSLAIN
TARRAGON LILL
MERCUME
MINT

NECESSARIE HERBS FOR PHYSICK~
ANNIS ARCHANGEL ANGELICA POPPY
GARLIC BETONIE HOREHOUND
CUMMIN DRAGONS LOVAGE
MUGWORT SMALLAGE
LICORAS RUBARB
MANDRAKE
VALERIAN
RUE

HERBS AND ROOTS FOR SALLETS AND SAUGES~
CRESSES CORNSALAD CHERVIL SALAD BURNET
ARTICHOKES SUCKERY RAMPION SAMPHIRE
TARRAGON ENDIVE CUCUMBERS LEMONS
OLIVES CAPERS ORANGES LEMONS
MUSTARD SEED GOOD KING HENRY
VIOLETS RED SAGE MARYGOLD
FENNEL PURSLAIN ROCKET
SPINAGE BASIL CHIVES
HAMBURG PARSLEY
RADISHES MINT
SKIRRET DILL
SEA HOLLY
SORREL
SAGE

BOX
VIOLETS
PERWINKLE
THYME MARJORAM
SAGE PRIMROSE PINK
ROSEMARY GRASS CUT OFT.
DOUBLE DAISY GERMANDER
LAVENDER SANTOLINA HYSSOP

HERBS TO SET KNOTS OR EDGE BEDS~
SUMMER LEEK
TURNIPS
CUCUMBERS
ARTICHOKE SAVORY
RED-RADISH-PODS ONION BEETROOT
ELDER-BUDS BROOM-MUSHROOMS PURSLAIN
THESE-ARE PICKLED FOR WINTER TARRAGON
SCENTED
FLOWERS OF~
COWSLIPS BURAGE
ARCHANGEL PRIMROSE
ROSEMARY ELDER VIOLETS
BROOM CLOVE-GILLIFLOWERS~
ARE PUT IN WINTER SALADS WHEN
PRESERVED IN SUGAR AND VINEGAR~

~HERBS & FLOWERS FOR POTS & WINDOWS
BATCHELORS-BUTTONS COLUMBINES
HOLLIHOCKS NIGELLA COWSLIPS DAFFADOWN-DILLIES
PINKES OF ALL SORTS MARIGOLD COLUMBINE BAY
EGLANTINE OR SWEET HEARTSEASE STAR OF JERUSALEM
VELVET-FLOWERS OR BRIAR GILLEFFLOWERS AND BETHLEHEM
MARIGOLDS COLUMBINE RUE LARKS-FOOT
SWEET WILLIAMS OR FRENCH LAVENDER
SNAPDRAGON ROSE
ROSMARIE
LILY

HERBS TO STILL IN THE SUMMER~
BLESSED THISTLE CRANBERRIES'
FUMETORY MINTS PLANTAIN
ROSES RED AND DAMASK
STRAWBERRIES DILL
ENDIVE SORRELL
SAXIFRAGE'
RESPIES'
HOP

REFRESHING HERBS TO STREW ON YOUR CHAMBER FLOOR
MEADOWSWEET, BASIL, FINE AND BUSH, BAULME
DAISIES SWEET FENELL, WATER MINTS'
COSTMAROY GERMANDER SANDAL~WOOD
MARJORAM PENNYROYAL COWSLIPS'
BURNET CEDAR~WOOD JUNIPER
WINTER~SAVORIE VIOLETS
LIME FLOWERS CAMOMILE
SWEET~WOODRUFF HOP
ROSES OF ALL SORTS
LAVENDER VIOLETS
SANTOLINA
LAVENDER SPIKE
LAVENDER
TANSIE
SAGE

BUDS
OF ROSES
BURAGE AND~
BUGLOS. SORREL
FLOWERS OF ARCHANGEL
SPROUTS OF BURNET. MINT.
VIOLETS WITH SOME TENDER~
LEAVES LIKEWISE PRIMROSES~
~SPRING SALAD OF YOUNG BUDS & SHOOTS
PEA
SUCCORY
PARSNIPS'
TURNIP STALKS
ENDIVE ONIONS LEEKS
WATER~CRESS ASPARAGUS
PUT WITH BUTTER OR VINEGAR
OIL CURRANTS, CINNAMON OR SUGAR
HERBS AND ROOTS USED FOR BOILED SALADS~
LIME
BERGAMOT
PEPPERMINT
YARROW ROSE SAGE
CAMOMILE SOAPWORT
ROSE-GERANIUM NETTLES
ORRIS ROOT LADY'S MANTLE DILL
LAVENDER VERBENA ROSEMARY TANSY
~HERBS FOR COSMETICS BEAUTY & VANITY.

Herein

A CHOICE OF HERBS
for your pot,
for salads and dishes,
cold or hot,
that they may bring a
touch of beauty
to even those
who eat
for duty.

And though here are
pressed: MARJORAM,
DANDELION, LOVAGE,
ANGELICA, BURNET,
and NASTURTIUM~
forget not the rest.

Dandelion-from
the French 'dent-
de-lion', perhaps
for the leaf shape
or yellow flower.

Burnet-delicate
plant, adds charm
to any garden.
Leaves have a
cucumber taste.

Lovage-with
umbels of yellow
flowers. Eaten
raw or cooked
as a vegetable.

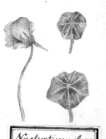

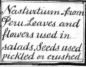

Nasturtium - from
Peru. Leaves and
flowers used in
salads, Seeds used
pickled or crushed.

Marjoram - Latin
'origanum' - means
'joy of the mountain'
a fragrant herb,
pink or white flower.

Angelica - for it
is told during
a plague how an
angel showed its
virtues to a monk.

Dandelions growing wild,
a salad of leaves and
wine of flowers. Angelica
and childhood memories
of their candied stems on
jewel-like cakes. Marjoram
to delight the senses, in
nosegays, sweet-bags or
wild it grows. Thoughts of
fresh Lovage and duck's
eggs omelettes at Bourne
Mill, when nasturtiums
climbed and tumbled with
bright flowers, and cool
drinks in which floated
perfect leaves of burnet-
the essence of summer.

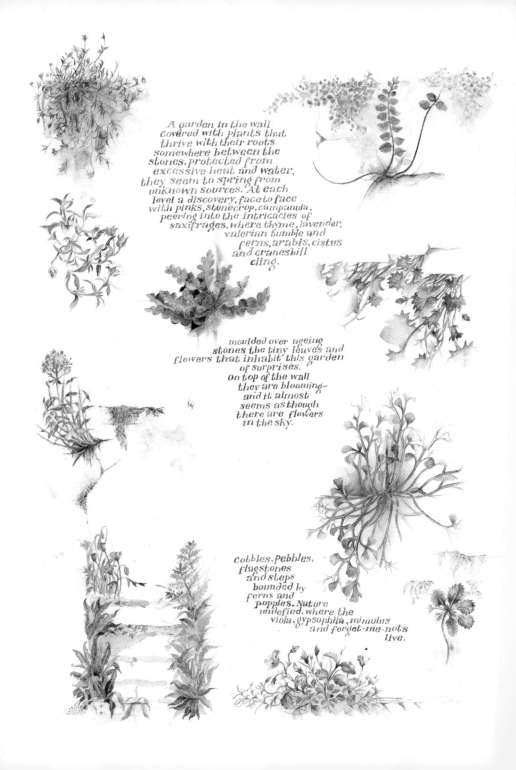

A garden in the wall
covered with plants that
thrive with their roots
somewhere between the
stones, protected from
excessive heat and water,
they seem to spring from
unknown sources. At each
level a discovery, face to face
with pinks, stonecrop, campanula,
peering into the intricacies of
saxifrages, where thyme, lavender,
valerian tumble and
ferns, arabis, cistus
and cranesbill
cling.

moulded over ageing
stones the tiny leaves and
flowers that inhabit this garden
of surprises.
On top of the wall
they are blooming—
and it almost
seems as though
there are flowers
in the sky.

Cobbles, pebbles,
flagstones
and steps
bounded by
ferns and
poppies. Nature
undefied, where the
viola, gypsophila, mimulus
and forget-me-nots
live.

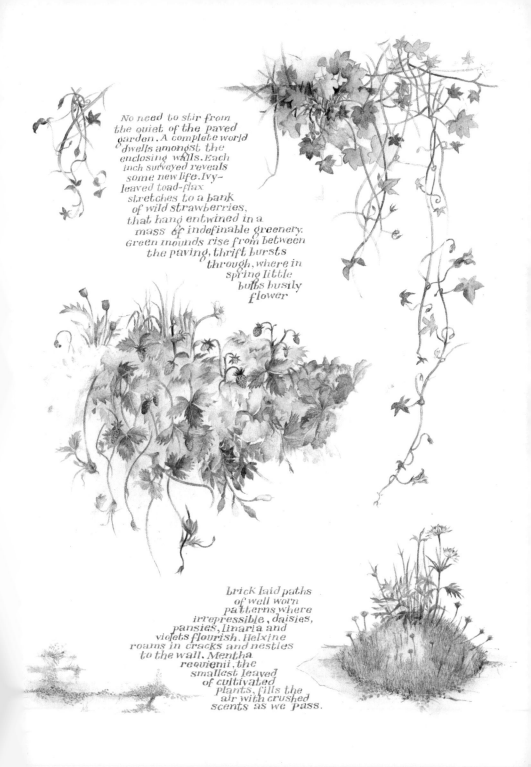

No need to stir from
the quiet of the paved
garden. A complete world
dwells amongst the
enclosing walls. Each
inch surveyed reveals
some new life. Ivy-
leaved toad-flax
stretches to a bank
of wild strawberries,
that hang entwined in a
mass of indefinable greenery.
Green mounds rise from between
the paving, thrift bursts
through, where in
spring little
bulbs busily
flower

brick laid paths
of well worn
patterns where
irrepressible, daisies,
pansies, linaria and
violets flourish. Helxine
roams in cracks and nestles
to the wall. Mentha
requienii, the
smallest leaved
of cultivated
plants, fills the
air with crushed
scents as we pass.

winter never killed this summer

My garden of pots is like some living diary,
a collection of **occasions**, memories, places
and friendships. Flowers exchanged, a fig-
tree given, campanula from a country-
garden, seeds from far-off places, morning
glory from a neighbour, your own geranium
cuttings, and a clematis for a special day....

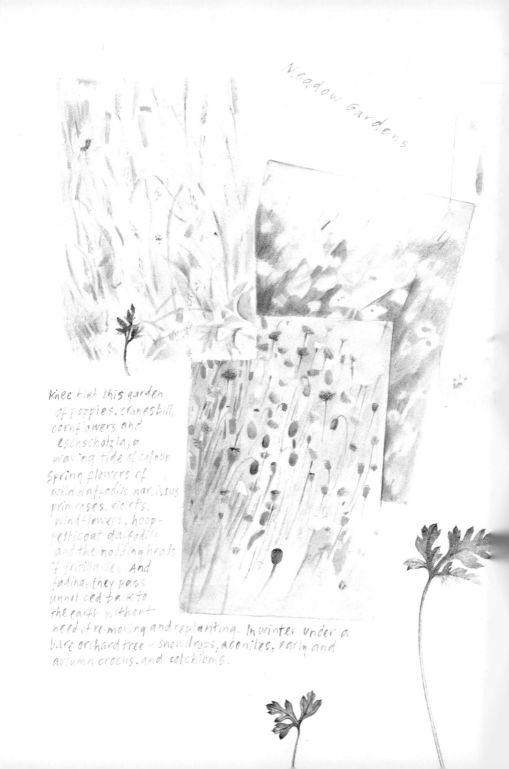

Knee high this garden
of poppies, cranesbill,
cornflowers and
eschscholzia, a
waving tide of colour.
Spring flowers of
wild daffodils, narcissus
primroses, violets,
windflowers, hoop-
petticoat daffodils
and the nodding heads
of fritillaries. And
fading, they pass
unnoticed back to
the earth without
need of removing and replanting. In winter under a
bare orchard tree — snowdrops, aconites, early and
autumn crocus, and colchiums.

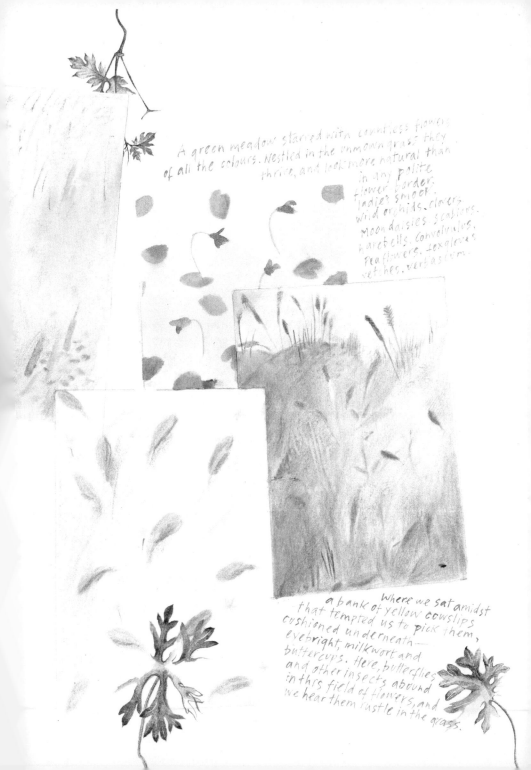

A green meadow starred with countless flowers
of all the colours. Nestled in the unmown grass: they
thrive, and look more natural than
in any polite
flower border:
ladies smock,
wild orchids, clovers,
moon daisies, scabious,
harebells, convolvulus,
fea flowers, foxgloves,
vetches, verbascum.

Where we sat amidst
a bank of yellow cowslips
that tempted us to pick them,
cushioned underneath—
eyebright, milkwort and
buttercups. Here, butterflies
and other insects abound
in this field of flowers, and
we hear them rustle in the grass.

Chamomile

'All parts of this excellent plant
are full of virtue.'

Lawns of mediaeval days were not close
cut patches of turf, but flowery meads
that grew freely like the natural
meadows, and were bedecked with many
flowers. With Tudor gardens came lawns
in the modern sense, and these were as
often planted with chamomile as grass.
Paths too were turfed with sweet herbs,
burnet, thyme and chamomile, and these
green areas trodden on and crushed,
thrived and perfumed the air most
refreshingly. In the fifteenth century
round the garden, beneath trees or
arbors, were brick seats cushioned
with low growing flowers like violets and
daisies. Here, and on fragrant banks of
chamomile that surrounded the
orchard one could sit and be cheered.
Chamomile, the plant doctor, put with
ailing plants may well revive them, as
it does many an ailing person.

'Perfumed Letter Paper' - If a piece of pea d'Espagne - (highly perfumed leather having been steeped in a mixture of rose, Lavender, Verbena, Bergamot, Clove & other ottos, with dissolved gum resins & gum-benzoin for a few days, then removed and left to dry. The skin is cut into squares & spread with a paste of civet, musk and gum acacia, mixed with a little of remaining otto, two pieces are sandwiched together, weighted, and left to dry for a week. Paper placed in contact with this Peau, absorbs enough odour, to be considered 'Perfumed'.

Underhill Cottage

HERBS FOR TEAS AND TISANES
FOR THE MIND AND BODY

HOW TO GATHER MAY. Sir H. PLATT. CLARISIS DELIGHT.

When there hath fallen no raine the night before then with a cleane large sponge, the next morning you may gather the same from sweet hearbs, grasse or corne: straine your dew and expose it to the sunne in glasses covered with papers prickt full of holes, strain it often continuing it in the Sun, and in an hot place, till the same grow white and clear, which will require the best part of the summer. Some commend May-dew, gathered from Fennell and Celandine most excellent for sore eyes.

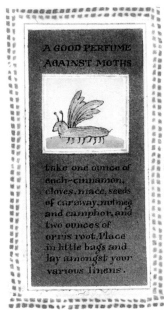

A GOOD PERFUME AGAINST MOTHS

Take one ounce of each - cinnamon, cloves, mace, seeds of caraway, nutmeg and camphor, and two ounces of orris root. Place in little bags and lay amongst your various linens.

TO CHEER the HEART and delight The Senses

A Cure For Insomnia and Melancholy

In a little bag, put the dried petals and leaves of roses, also some powdered mint, and cloves. Placed by the bed this scent, should induce sleep and at other times ~ cheer the soul.

FOR
Absent Hair.

THE ashes of *southernwood*, mixed with old salad oil will cause a beard to grow or hair on a bald head

TO KEEP THE TEETH BOTH WHITE & CLEAN.

Take a quart of honey, as much vinegar, and half so much of white wine, boil them together; and wash your teeth therwith now and then.

The soothing, calming or soporific infusion of flowers or leaves of herbs, either fresh or dried, amongst which are used— Alecost, Balm, Dill, Violets, Mints, Cicely and many others.

LOTIONS AND POTIONS~ for Varied Notions.

Take some Carmine and mix it with hair-powder to make it as pale or dark, as you please.

Mrs. Glasse

French Rouge

PERFUME FOR GLOVES AND HANDKERCHIEFS.

Ambergris, 1 dr. Civet, 1 dr. Oil of Lavender oil of Bergamot 3 drs. Camphor ¼ oz. Spirit of wine, 1 pt. Cork & shake well for 10 days filter and bottle.

Eau ~de Cologne
one pint rectified spirit one ounce orange flower water, 2 drams bergamot oil, 2 drams lemon oil, 20 minims oil of rosemary, 20 minims oil of neroli Leave for a few months, shake at intervals.

TO TAKE AWAY
SPOTS OR FRECKLES

From the face or hands

SIR HUGH PLATT.

THE sappe that issueth out of a Birch tree in great aboundance, being opened in March or Aprill, with a receiver of glasse set under the boring thereof to receive the same, doth perfume the same most excellently and maketh the skin very cleare. This sap will dissolve pearle, a secret not known unto many.

A DAINTY FOR THE ... PERFUME BREATH

the white of an egg, the juice of lemon a little sugar, one dash of rosewater and almond oil. These must be beaten for hours then bottled. Half a dozen drops in a glass of water will make the breath sweetly smell.

FOR A SWEET BATH

Take~
Two handfuls of~ Sage, Lavender, Rose and Sweet Flowers, and a little salt, boil them in water, and make a bath, not too hot, in which to bathe the body in the morning or two hours before the meat.

A BATH FULL OF FRAGRANCE

A PERFUME TO PERFUME ANY SORT OF CONFECTIONS

TAKE MUSK, THE LIKE QUANTITY OF OIL OF NUTMEG, INFUSE IN THEM ROSE-WATER, AND WITH IT SPRINKLE YOUR BANQUETING PREPARATIONS & THE SCENT WILL BE AS PLEASING AS THE TASTE.

The powder of the seedes of elder first prepared in vinegar, and then taken in wine half a dramme at a time for certaine dayes together is a meane to abate and consume the fat flesh of a corpulent body and to keep it well leane. This~ A remedy by Parkinson

AGAINST INDULGENCE

AGAINST FAT

PETROSELINUM

"The excellency of this herb, accordeth with
the frequent use thereof. For there is almost
no meate or sauce which will not have
Parsley either in it or about it.
The chiefest vertue lieth in the roote:
second in the seed: last and least in the
leaves and yet these are of most use in
the kitchen." Henry Buttes
"Parsley is very convenient to the stomach
and comforteth appetite, and maketh
the breath sweeter." Syr: Thomas Elyot

PARSLEY

"As for Rosemary I lette it runne all over my garden walls,
 not onlie because my bees love it,
 but because it is the herb sacred to remembrance
 and to friendship, whence a sprig of it hath a dumb language." Sir Thomas More

 When Tudor ladies with fanciful thoughts of topiary, fashioned shapes
 of hunting parties, peacocks and vast imaginings from their Rosemary
 bushes. They passed under shaded alleys of arched trees where hedges
 of lavender, Rosemary, sage and southernwood, intersperced with roses,
 filled the air with their heady scents.

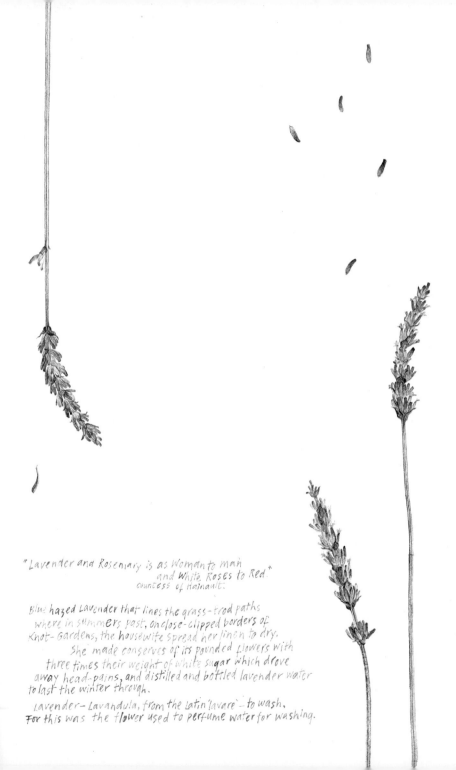

"Lavender and Rosemary is as Woman to man
 and White Roses to Red."
 Countess of Hainault.

Blue hazed Lavender that lines the grass-trod paths
 where in summers past, on close-clipped borders of
Knot-Gardens, the housewife spread her linen to dry.
 She made conserves of its pounded flowers with
 three times their weight of white sugar which drove
 away head-pains, and distilled and bottled lavender water
to last the winter through.

 Lavender-Lavandula, from the latin 'lavare'- to wash,
For this was the flower used to perfume water for washing.

RUE

Rue-the herb of Grace, of scents realized before the gentle foliage is spied from amongst the flower border. Often clipped into hedges by the Elizabethans to enclose their Knot-gardens and mixed in judges' tussie-mussies that they carried as a protection from jail-fever.

A favourite of bees and when in a jug of flowers on the table sends out enchanting scents. The Latin name-Melissa-is from the Greek for Bee, and if rubbed inside a hive it encourages newcomers to stay. Good for students as it 'encreaseth the memory' and drunk in wine 'drives away melancholy' John Gerard said.

LEMON BALM

Fern like leaves and umbels of delicate white flowers that are of the loveliest of herbs. The Romans showed us its uses in garnishing dishes hot or cold and thus it adds a faintest hint of 'aniseed 'It should never be wanting in a sallet, being exceedingly wholesome and cheering'. said Evelyn.

CHERVIL

Salvia officinalis — from the Latin- 'salveo'- I am well, for it is said to cure all ills hence 'how can a man die who has sage in his garden?' Grey-green of herbs that is as good a companion for onions in the earth as inside a cooked — fowl. Cuttings taken 'and planted in May— will grow every day'...

SAGE

Hyssop and radishes may be enemies & grown near beans hyssop repels blackfly, but to bees it is a herb of great appeal with flowers blue, white or pink. Rooms strewn with hyssop clippings & filled with its scent were once favoured. Tea of the flowers helps cure chest problems.

Ancient Greeks and Romans esteemed this plant, & made crowns of it to honour their victors. Grown in tubs & cut to formal shapes it is most decorative & thus easily moved to escape the cold. Yielding a growing supply of leaves, which when dried form a part of bouquet garni and are used in a variety of dishes.

Sweet Basil rewards a human touch with pungent aromas that 'taketh away sorrowfulness'. A sacred herb from India, & sown by Ancient Greeks with insulting words, to make it grow. In some countries, used as a test of chastity-withering in the hands of the impure, but a man taking basil from a woman-will love her always.

Crushed scents of mints pervading, apple, lemon, eau-de-cologne but a few of the many varieties, captured in sachets or pot-pourris. Fresh tastes in summer dishes, drinks & dainties, the much-loved mint sauce that stirs the appetite for meat. A valuable plant since bible-times & one of the first used medicinaly.

Sweet smells that change with passing hours.
Summer days and evenings in a scented herb-
garden, on seats or banks cushioned with thyme
or daisies. With fragrant paths of pennyroyal
or water mint. Borders edged with chives, pinks,
lavender-cotton or hyssop, wherein grow plants of
lemon balm, alecost, angelica, chamomile, cat-
mint, feverfew, scented-leaved geraniums, lily-
of-the-valley, lavender, white horehound, rue,
mignonette and anise. The many varieties of
mint — eau-de-cologne, apple, peppermint, orange,
pineapple, lemon, and spearmint. Musk, tansy,
southernwood or lad's love, sweet cicely and
jasmine. Knotted marjoram often picked
with divers other herbs, flowers and plants
as a favourite to be put in nosegays of
assorted scents and colours.
Lemon thyme, wild thyme,
tobacco-plants, coriander,
dog rose, wild rose and
old fashioned roses. Sweet
woodruff, wormwood,
pansy 'heart's ease',
artemesia, lemon-balm,
lemon verbena, bergamot; iris,
melilot, costmary, lovage,
red sage, green sage, and
violets both white and mauve.

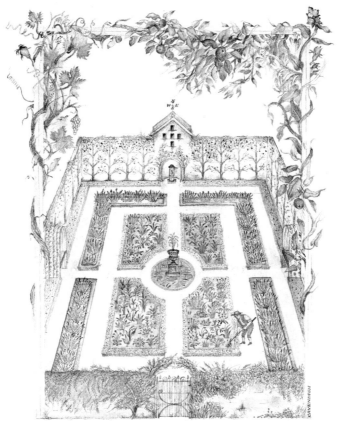

"My Garden sweet, enclosed with walles strong,
Embanked with benches to sytt and take my rest."

north
north nor
wind th
northwind h
wind

"Awake, Oh North wind;
and come, thou south
blow upon"

hyssop cumin balm caraway dill poppy mint saffron
cinnamon anise caraway mint
mint balm cumin dill anise caraway mint cum
anise hyssop saffron poppy mint jasmin saffron j
jasmin cinnamon ginger spikenard mint
dill marjoram cumin
marjoram balm mint pk i
jasmin hard mint s
balm spike saffron
dill spike saffron myrrh anise kn
dille anise ny
ginger saffron cumin jasmin
dill mint dill balm dill poppy
mint dill balm dill poppy
cinnamon caraway saffron
cinnamon poppy saffron roy
mint sm saffron p
ja

"...y garden, that the spices thereof may flow out."

SOURCE BOOKS

It is difficult to credit all the material as a number of pieces were anonymous, but where I have used quotes, and whenever possible, the author has been named. From the many old books which I have gratefully drawn inspiration, information and many hours happy reading, I would like to mention the following;

Austen, Ralph. *A TREATISE OF FRUIT TREES.* 1653

Bagster, Samuel. *THE MANAGEMENT OF BEES.* London. Saunders & Otley. 1838.
 ('Prone to revenge, the bees, a wrathful race...')

King James Version. *THE BIBLE.*
 ('Awake, O North wind;) Solomon's Song 4:16

Buttes, Henry. *DYETS DRY DINNER.* London. 1699.

Cobbett, William. *THE ENGLISH GARDENER.* London. 1833.

Cox, E. H. M. Editor. *THE GARDENER'S CHAPBOOK.* London. Chatto & Windus. 1931.

Evelyn, John. *KALENDARIUM HORTENSE.* London. 1664
 ———— *ACETARIA: A DISCOURSE OF SALLETS.* London. 1699.

Gardiner, Richard. *PROFITABLE INSTRUCTIONS FOR THE MANURING, SOWING AND
 PLANTING OF KITCHIN GARDENS.* London. 1603.

Glasse, Mrs. Hannah. *THE ART OF COOKERY MADE PLAIN & EASY.* London. 1803.
 (Green Peas and Cream.)

Hyll, Thomas. *THE PROFITABLE ART OF GARDENING.* London. 1568.
 ———— *THE GARDENER'S LABYRINTH.* London. 1577.

Hurlstone Jackson, Kenneth. *A CELTIC MISCELLANY.* London. Routledge Kegan Paul.
 1951. (From the Poem, 'The Hermit's Hut.' _ "I have a hut in the wood.")

Lawson, William. *A NEW ORCHARD AND GARDEN.* London. 1618. 1927

Leighton, Ann. *EARLY ENGLISH GARDENS IN NEW ENGLAND.* London. Cassell. 1970.
 (Four lines of a poem by William Bradford.)

Markham, Gervase. *THE ENGLISH HUSBANDMAN.* London. 1613.

Meager, Leonard. *THE ENGLISH GARDENER.* London. 1670.

Miller, Philip. *THE GARDENER'S DICTIONARY.* London. 1733.

Parkinson, John. *PARADISI IN SOLE PARADISUS TERRESTRIS.* London. 1629.

Platt, Sir Hugh. *DELIGHTS FOR LADIES.* London. 1609.

Rohde, Eleanour Sinclair. *THE OLD ENGLISH GARDENING BOOKS.* London.
 The Minerva Press. 1924. 1972.
 ———— *THE STORY OF THE GARDEN.* London. The Medici Society. 1932.
 ———— *A GARDEN OF HERBS.* London. The Medici Society.

Tavener, John. *CERTAINE EX-PERIMENTS CON-CERNING FISH & FRUITE.* London. 1600.

Tusser, Thomas. *FIVE HUNDRED POINTES OF GOOD HUSBANDRIE.* 1580.

Worlidge, John. *SYSTEMA AGRICULTURAE.* London. 1669.
 ———— *SYSTEMA HORTI-CULTURAE.* London. 1677.
 ('What living creature can you keep about you....')